EXPLORERS
OF LIGHT

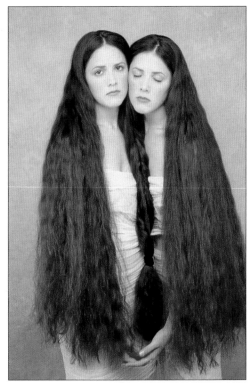

JOYCE TENNESON, TWINS, 1995

EXPLORERS OF LIGHT

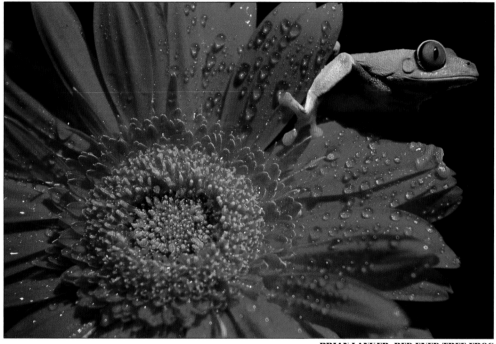

Introduction by
Richard B. Stolley
Text by
Claudia Glenn Dowling
Technical Information
by Don Leavitt
Design by
Hopkins/Baumann

CANON U.S.A., INC.

CONTENTS

Introduction © 1996
by Richard B. Stolley
Text © 1996
by Claudia Glenn Dowling
Technical Information © 1996
by Don Leavitt
Photographs © 1996 by the
individual photographers

First Edition

Library of Congress
Catalog Card Number: 96-86481

ISBN 0-922826-90-0

Published in the United States
by Canon U.S.A., Inc.
Lake Success, New York

10 9 8 7 6 5 4 3 2 1

Printed in Hong Kong

Designed and produced by
Hopkins/Baumann, New York
Designers: Will Hopkins,
Mary K. Baumann
Managing Editor: Jennifer Dixon
Copy Editor: Paula Glatzer

INTRODUCTION
BY RICHARD B. STOLLEY

HE WHO CAN, DOES; HE WHO CANNOT, WRITES INTRODUCtions. That paraphrase of George Bernard Shaw crossed my mind as I looked over the superb photographs in this book. What can I do, I asked myself, to add to the simple enjoyment of studying them, reading the elegant accompanying text and perhaps learning a technical lesson from each picture (in a section at the back of the volume, which should fascinate even the amateur who doesn't know his f-stop from his elbow).

My shortcomings should be made clear. Aside from some prejudices about photography (e.g., sharp is always better than fuzzy), I am not a bona fide critic. My attitude can be summed up in that awful cliché: I know what I like, or more precisely, what I think readers will like (and I mean people who read pictures as well as words). One way or another, I have worked for readers all my professional life, which is to say since the age of fifteen, when I was hired at $25 a week as sports editor of the Pekin, Illinois, *Daily Times.* I wrote stories about high school football and church league softball, and with teenage trepidation selected pictures of these important events too. It was my first experience in using photography to complement and augment and sometimes substitute for words. I've been learning ever since.

So if not a critic of photography, what am I? The answer to that is: a friend of photographers, not just as a magazine editor laying out their stories but, more important, as a reporter working side by side with them in the field. I hung out of small airplanes in upstate New York with Margaret Bourke-White, returned to the Philippines with General MacArthur and Carl Mydans, pursued youth gangs in Brooklyn with Alfred Eisenstaedt, searched for the missing Michael Rockefeller in New Guinea with Eliot Elisofon, watched rockets blow up in Florida with Ralph Morse, landed in Haiti with American troops and Harry Benson, etc.

These adventures, and many others not quite so exotic, have left me with some firm feelings about photographers. Even though I do not personally know most of the men and women who contributed to this book, I think I can pass judgment on them and their species, largely by the pictures they took and the explanations they offered.

It is a reckless undertaking, you may say, but that is one of the traits I so admire about photographers. They are a reckless, fearless bunch, not just in combat or racial violence, as I have witnessed, but in their whole approach to their art. "That little box in front of us protects us, gives us license," says one represented in this book. It is admirably true. Photographers constantly want to try something new—new equipment, like the fancy camera, the Canon EOS System, used for this book; new challenges, like a fashion photographer in a maximum security prison; new dangers, like an Alaskan mountain seen from four miles up in the sky.

Good photographers do not alibi. They sometimes talk a tad pretentiously about themselves when someone with a pad and pencil is around, a kind of daguerreah, and you may discover a few examples in these pages. But photographers are generally dead honest about their work. They know when they've nailed the shot, completed the assignment. And when they haven't, they know that too. Contrary to a belief held by a lot of editors, photographers are usually the best judges of their own work.

This book is testimony. The fifty-five photographers were asked to submit pictures shot with the Canon EOS; one responded with forty images, another with five, and the others were in between. It is a tribute to the designers, Will Hopkins and Mary K. Baumann, but also to the photographers' own taste and confidence that only one objected to the final selection, and only hesitantly and briefly. The picture is still here. (No, I'm not going to tell you which it is.)

The images in this book not only resonate on their own, but some also remind me of earlier classics, which suggests that all fine photography, resembling the happy family, is essentially alike. The skateboarder evokes memories of Ralph Crane's famous boy running in a hall; the wedding couple in the garden, of W. Eugene Smith's unforgettable children in a bower.

O<small>NE OF THE DELIGHTS OF THIS BOOK IS ITS INFINITE VARIETY. I</small><small>TS</small> title is *Explorers of Light,* but its subtitle could well have been *...and the Eclectic Too.* For anyone picking up this book, much of the fun will be to turn the page without the slightest notion of what's coming next—a spectacular hot spring in Yellowstone that looks like the center of the earth, a vase and flower composed entirely of shadow not substance, a swimmer in a pool of blood that is really a red lane line. These are the adventures in imagination that photography of this caliber brings.

I do not wish to quarrel with Henri Cartier-Bresson, but "the decisive moment" has never quite explained great photography to me. As I think any photographer will attest, there are many decisive moments during an assignment or a shoot. "For a split second," a photographer in this book says, "I see a sparkle of beauty passing by." She is speaking, I believe, not so much about the decisive moment, as the unreturnable moment, the unrecapturable moment. Such moments are caught in memorable photographs, and you will find them in more than a few pages here.

There's an old saying that journalists go into the profession because they meet so many interesting people—and most of them are other journalists. It is certainly true of photographers. I've rarely met a dull one. They tell good stories; they speak of their work with passion, almost never with the cynicism that clogs the hearts of too many of their print colleagues.

The venerable Boy Scout Oath describes members as being courteous, obedient, clean and reverent, among other virtues. They are not adjectives I would apply liberally to photographers—not to my friend who always went to sleep with a six-pack as a pillow, nor to another who, when asked if he was married, replied, "No, but my wife is." How then would I de-

scribe photographers? From my experience, overwhelmingly generous. It always surprised me that photographers in highly competitive situations were often so willing to help out their putative rivals, from both magazines and newspapers. I actually saw one friend of mine hand over an extra roll he'd shot to a colleague who had arrived too late for an interview. And generosity does not end with professional help. A photographer in this book gave her own money, I know, to relieve the misery of a destitute family she was covering.

WHEN I DISCUSSED MY INTRODUCTION WITH A WELL-KNOWN ART director who deals with photographers constantly, he spoke of their "tender egos." It is perhaps the other side of generosity. In any case, I regard such sensitivity as inevitable; their work, like the model's face, is out there for the world to see. Ambiguity is the province of writers, not of photographers. What you get is what the photographer saw, stark and real. It takes boldness to critique a piece of writing. All it takes to critique a photograph is a look. The world is full of would-be picture editors. Who can blame the photographic ego?

Maybe that is a good thing, for it creates an awareness of photography as the most accessible of the arts, and arguably the most powerful. The thought is expressed in this book's appropriate title. The theme of exploration has been plumbed for centuries, with wonder and excitement, but perhaps never so magically as in T. S. Eliot's verse from "Four Quartets":

> *We shall not cease from exploration*
> *And the end of all our exploring*
> *Will be to arrive where we started*
> *And know the place for the first time.*

The subjects in this book range from the exotic to the everyday, the quaint to the quotidian, but its authority is such that we truly feel we are seeing these things, these people, for the first time.

BARBARA BORDNICK

"The thing that fascinates me is mystery, not the what-you-see-is-what-you-get," says Bordnick. "If I look out of a window, it's not what I see that interests me so much as what I *could* see." What she does see—and transfers to film—is a lyrical grace shared by her portraits, nudes and fashion images, like this one for *The New York Times Magazine*. "In fashion, you have a fantasy, and you hope that someone will come along for the ride," she says. "Photography is all about fantasy, really, doing things you wouldn't dare do in other aspects of your life. That little box in front of us protects us, gives us license." Such artistic risks pay off. "Friends tell me my work looks like me—not what I look like, but what I am," she says. The same can be said for the work of all great photographers.

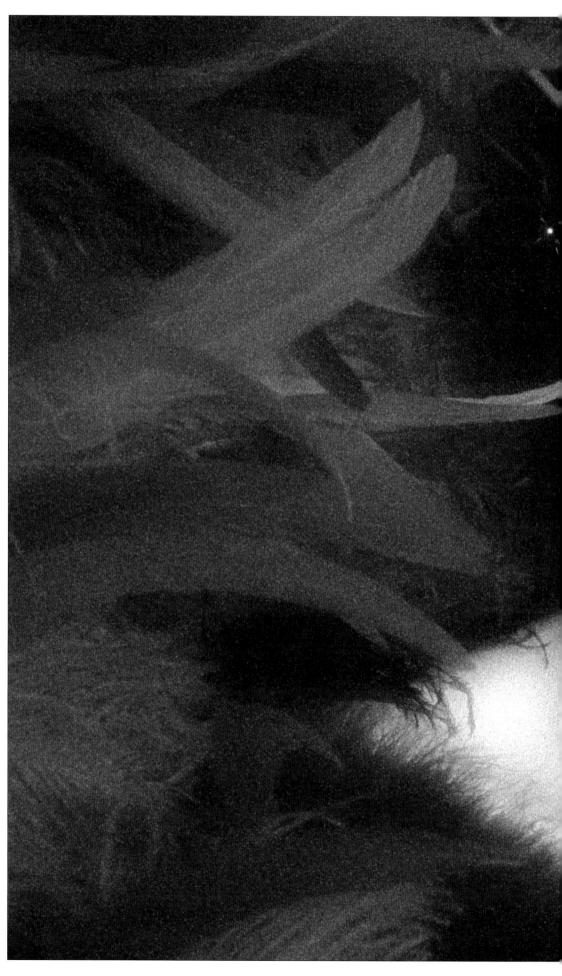

BERNADETTE IN FEATHERS, 1995

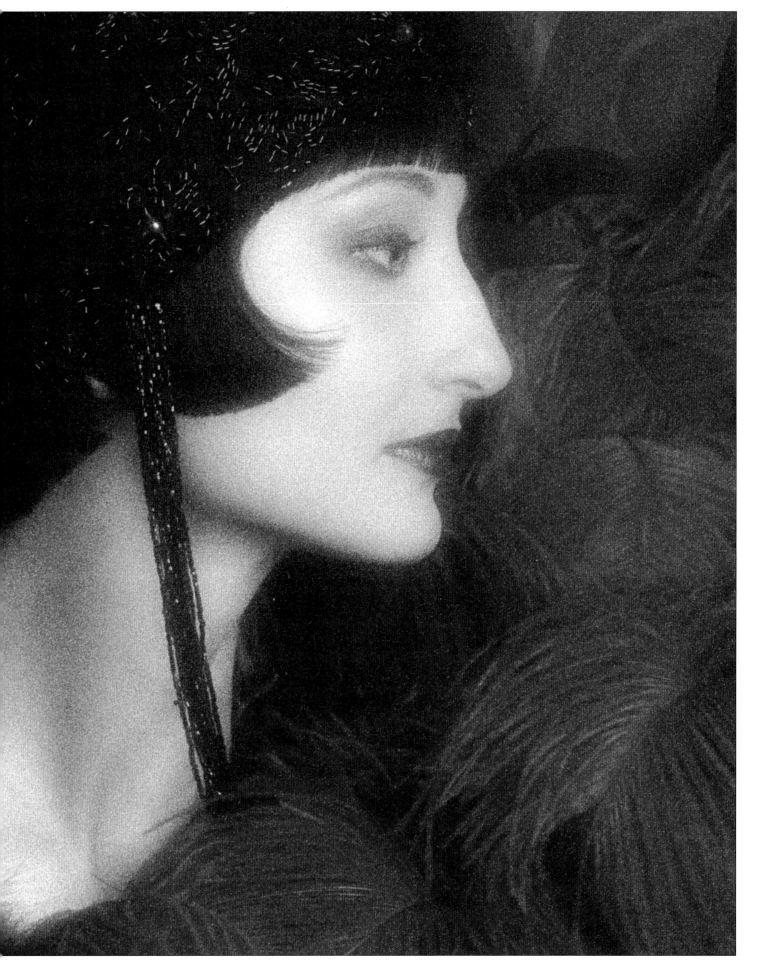

ARNOLD NEWMAN

For six decades, whether shooting Pablo Picasso, Frank Lloyd Wright or John F. Kennedy, Newman has evoked the essence of personality. When he began work in chain portrait studios in 1938, everyone used standard backdrops and studio props. "You couldn't tell a CEO from a foreman on the assembly line," says Newman. He is credited with originating the environmental portrait, in which the sitter's surroundings are meaningful. "All the objects in the pictures create a mood, reflecting a person's personality—and how I feel about that person," he says. These days, a Slovak photographer *(above)* or a Japanese talk show celebrity *(right)* may visit his New York City studio, and he makes do without environments. Still, when Tetsuko came to pose, "I insisted that she bring that dress—her clothes are part of her persona."

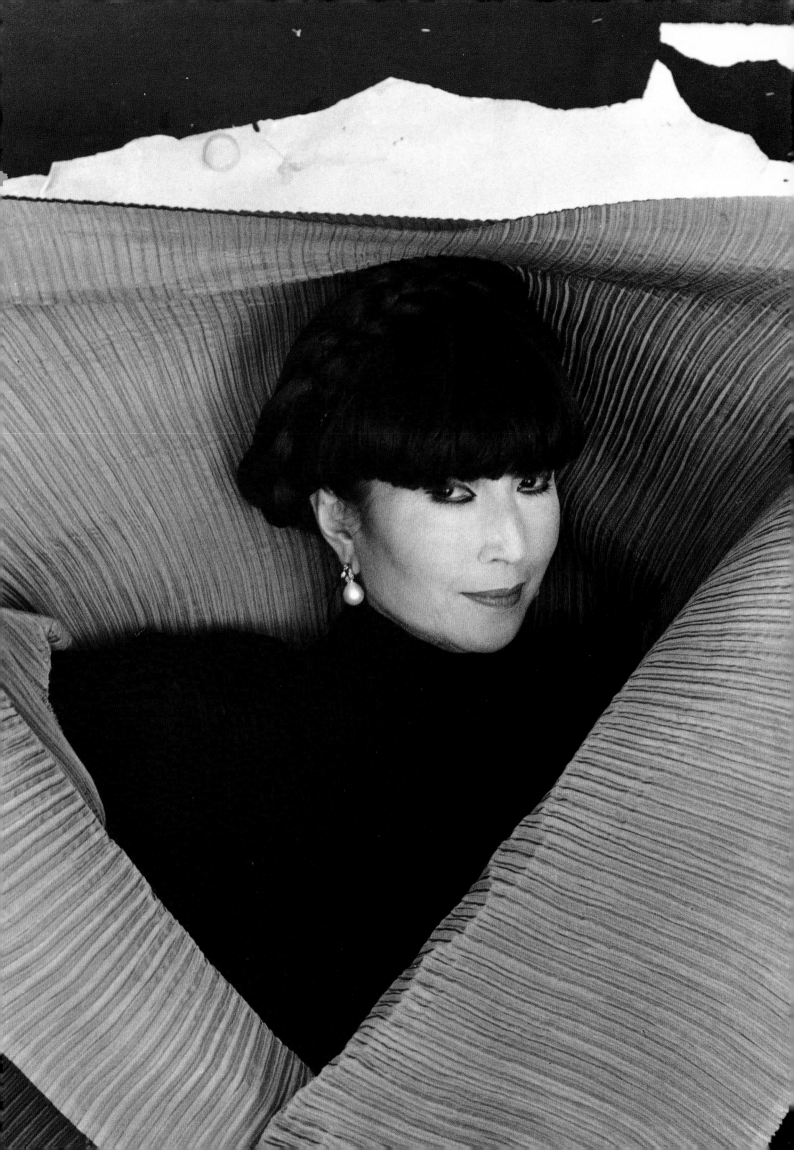

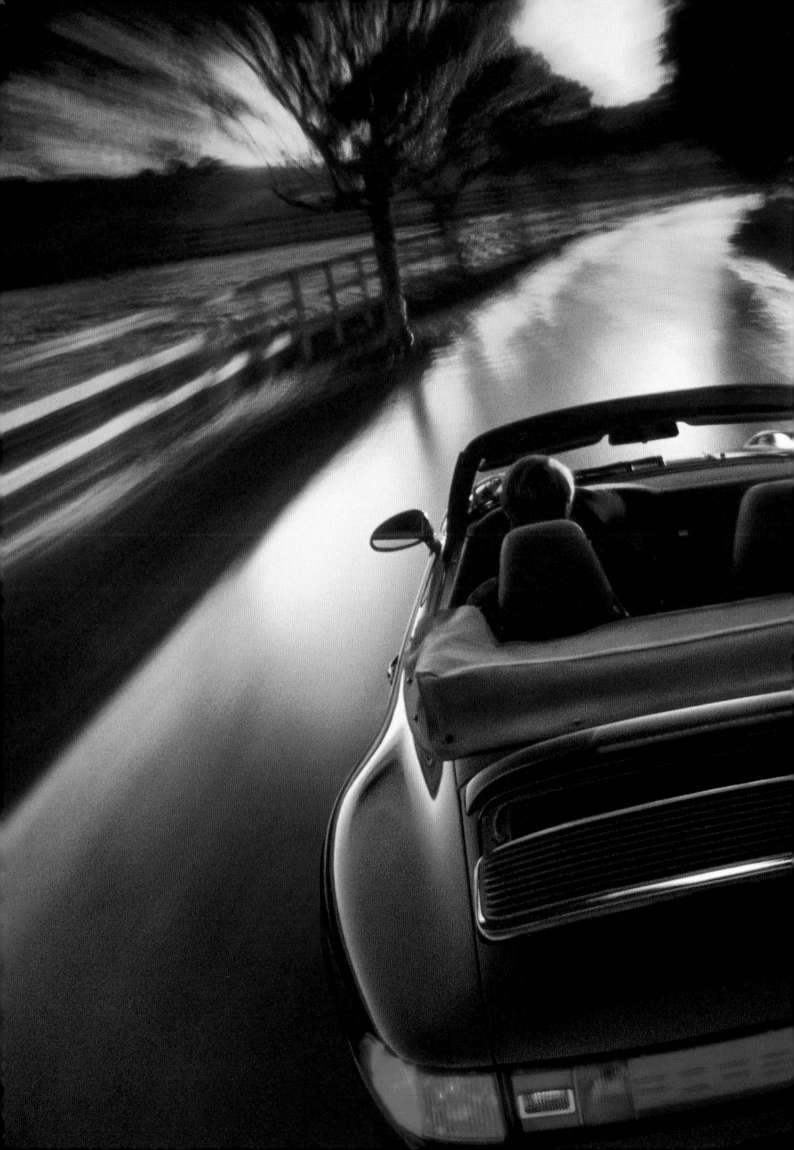

PORSCHE 944. 1995

PARISH KOHANIM

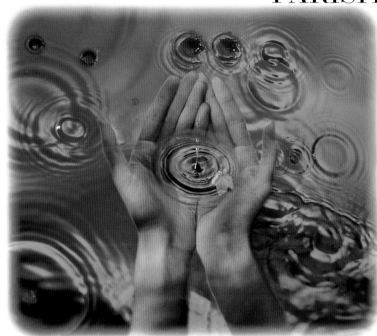

ESSENCE OF LIFE, 1995

The two poles of planning
and spontaneity intertwine
in Kohanim's best photo-
graphs. For a New Age
musician's CD package
(left), the concept was
spontaneous but the
execution meticulous,
requiring three shots—one
of hands, one of water
drops, and one of a pool of
water. The shooting of the
tulips in a reflection of a
vase was simpler, one
smooth process from
concept to execution. "I
just got inspired—I was so
excited, I was perspiring,"
says Kohanim. "I let it
happen, it flowed." The
meanings hidden in each
frame are as fragile as a
flower or a raindrop, he
says, best interpreted by
the viewer.

◀ **PRECEDING PAGES**

CLINT CLEMENS

"Things that move"—things
like a Porsche Cabriolet
on a road in Santa Ynez,
California—are Clemens's
preferred subjects. Here he
used a telescoping boom
arm he patented himself,
firing the camera by remote
control. As usual, Clemens,
a many-times-great-nephew
of Sam Clemens (a.k.a.

Mark Twain), was at the
wheel, pedal to the metal. "I
usually see things in mo-
tion," says the Rhode
Island–based photographer.
Not surprisingly, he travels
more than 150,000 miles
a year. "Wait for the mo-
ment, get it, and go," is his
modus operandi. "I open
my eyes, and that's the way
it comes out."

PROGRESSION, 199

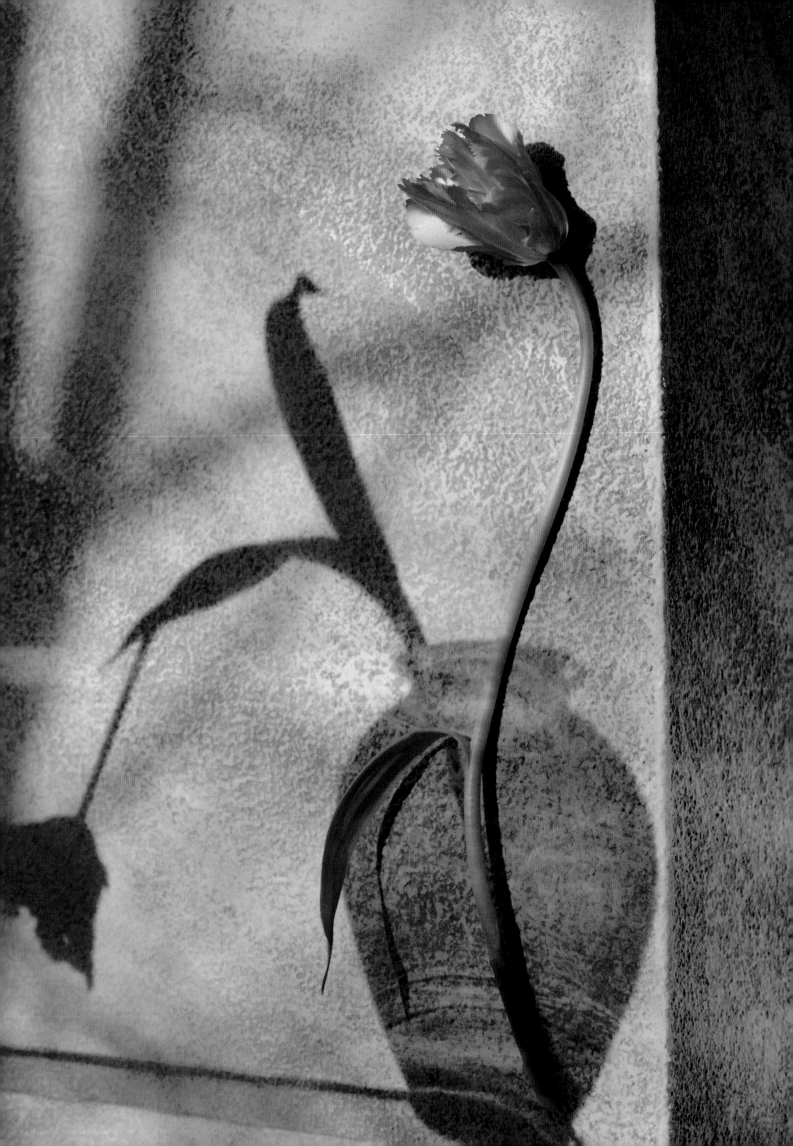

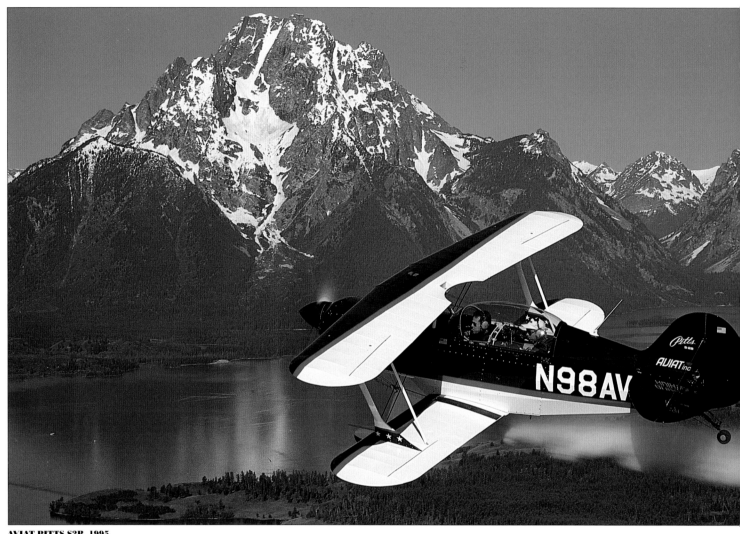

AVIAT PITTS S2B, 1995

MICHAEL FIZER

The son of a fighter pilot, Fizer never intended to specialize in aviation. "You take some good pictures of airplanes, and before you know it, you're not a studio shooter anymore," he says. A staffer for a pilots' magazine, he shoots all manner of noncommercial craft—from the small, classic, fun-of-flying Pitts biplane (over th Grand Tetons, *above*) to a corporate jet (near his home in Wichita, Kansas, *right*). His favorite air-to-air assignment is aerobatics, in which the "platform pilot" flying the plane he's in has to match loops with the

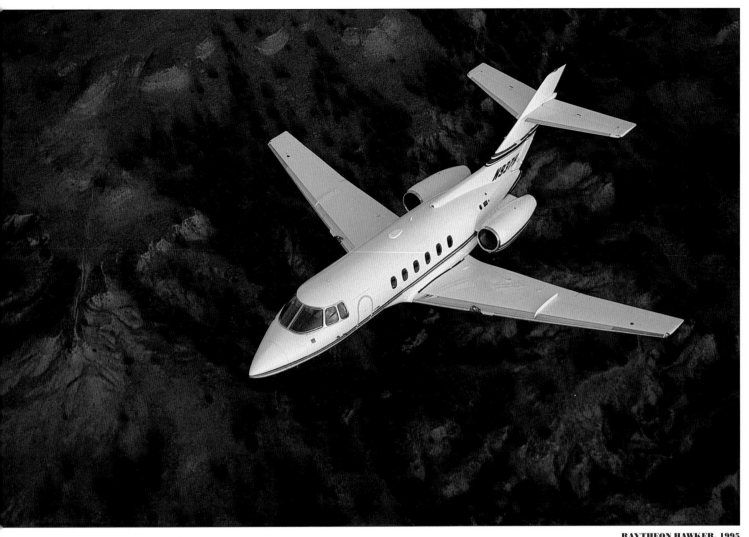

plane he's photographing.
"It seems as if you can
reach down and touch its
wings. The wind is rushing
around, because I'm almost
hanging out the open door.
It's an aerial dance," says
Fizer, who carries a million-
dollar life insurance policy.
"It's darn fun."

ARTHUR ELGORT

If his pictures have a flaw, says the fashion photographer, it's that they don't—his subjects look "too pretty." When he first hung out his shingle at Uta Hagen's acting studio in New York City, Elgort did publicity shots for aspiring actors, charging $40 for four rolls. "I wasn't from the Diane Arbus school," he jokes. "Your job is to make 'em look so good, they want to come back." Over the years, he has found that to make people look good, he must make them feel good. For this British *Vogue* shoot, he assembled young models, hair and makeup people, stylists and editors, and encouraged them to do their best work. "So much has to do with the room they're in, what happened that day, how they hit it off. If they're proud—it radiates," he says. And they look great.

CAROLINE AND MICHELLE, 1995

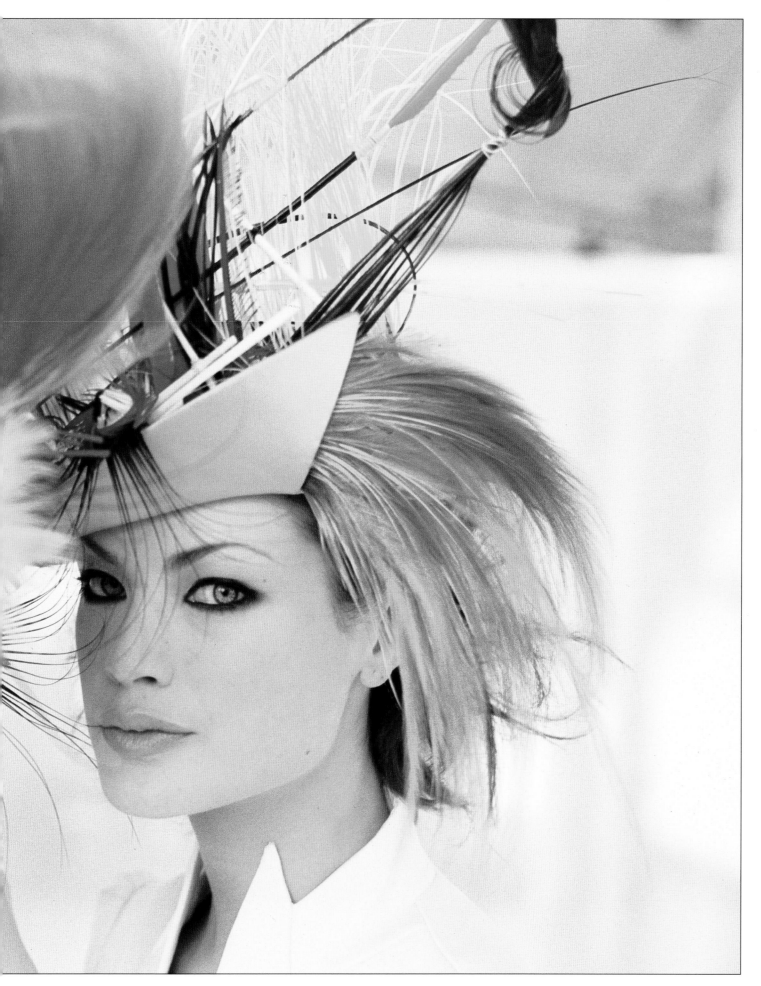

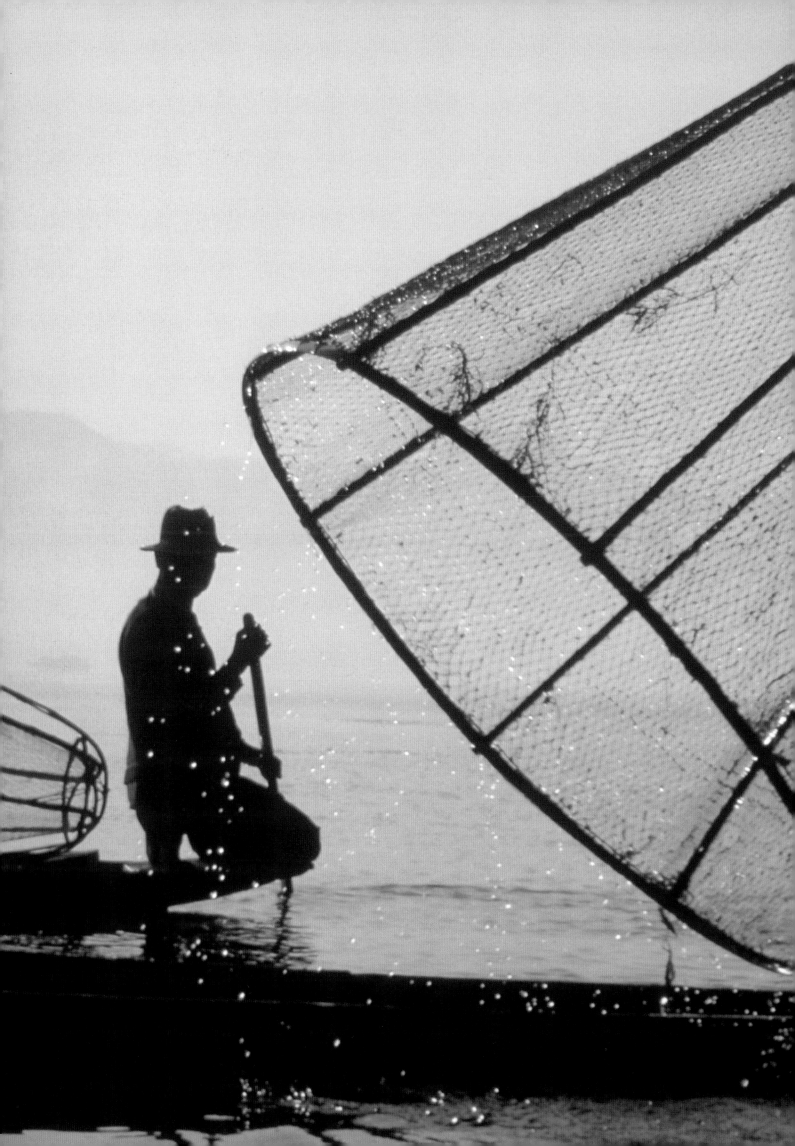

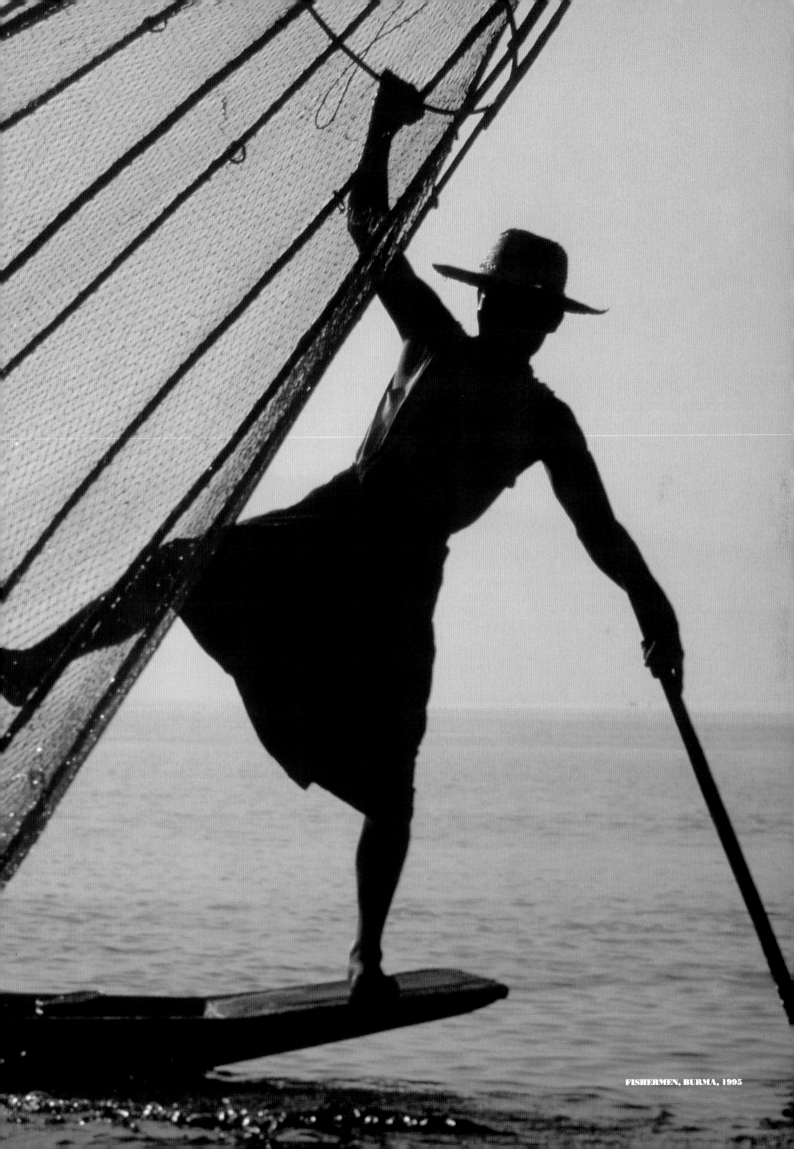

FISHERMEN, BURMA, 1995

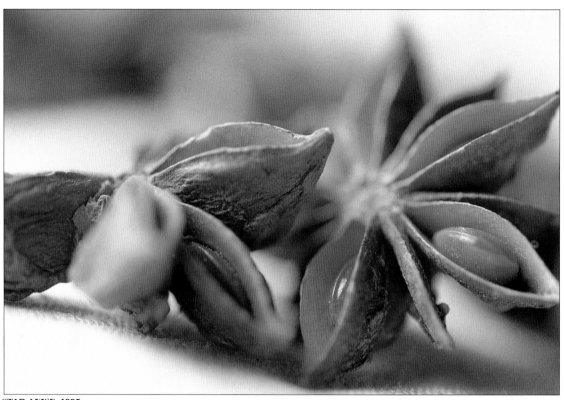

STAR ANISE, 1995

BETH GALTON

"I like things in themselves, things that are corporeal and curvaceous, that reflect the reality of the moment," says the still-life artist. These particular objects entered her studio as props, but Galton quickly sensed greater possibilities. She liked the shapes the seed pods made in the anise, the shadows and curve of the napkin. Her technical expertise, honed as a studio assistant years ago, allows her to manipulate reality to produce just the effect she wants. "I like sculpting with the light," she says, "creating dimension and form with it."

◄ **PRECEDING PAGES**
ERIC MEOLA

After seeing *Lawrence of Arabia* as a teenager, Meola wanted to visit exotic places. As a travel and advertising photographer, he has lived the dream. On a swing through Asia, he stopped in Burma, only recently opened to visitors, on a "self-assignment." He followed this boat out into Inle Lake and got one frame as the fisherman prepared to push his trap into the water with his foot. It was the graphic design that intrigued Meola—that and its away-from-the-rest-of-the-world aura. "It's just something that's always been in my blood."

LINEN WITH PEARLS, 1995

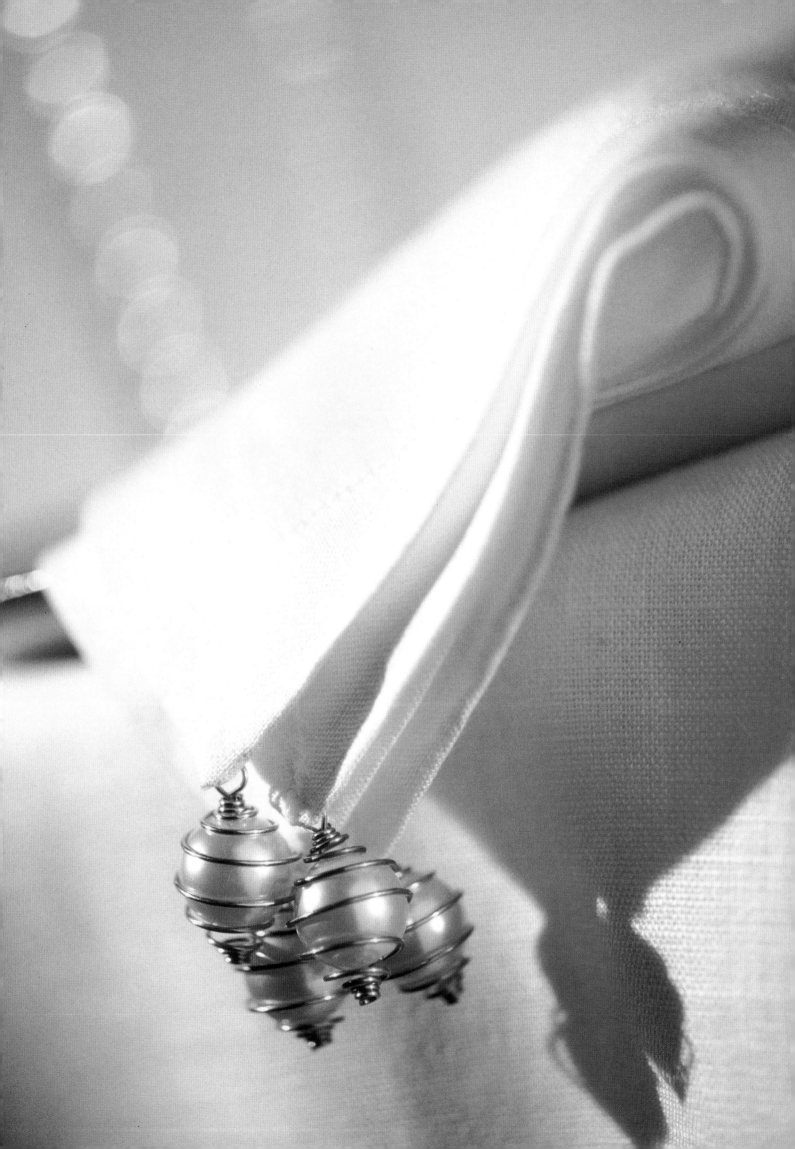

MARY ELLEN MARK

Beauty is in the eye of the beholder. Ashley Damm, six, and her sister Summer, four, play beauty school near the shack with no running water that their homeless parents have occupied for several months. "They were squatting in this filthy place," says Mark. "But they were fixing themselves up like any little girls before going to school—except they didn't go to school. They had a poignant dignity." A photojournalist often drawn to people living on the edges of society, Mark finds loveliness in the ugliest circumstances. Her best photographs are, like these girls, treasures found in the ash heap.

ASHLEY AND SUMMER, 1994

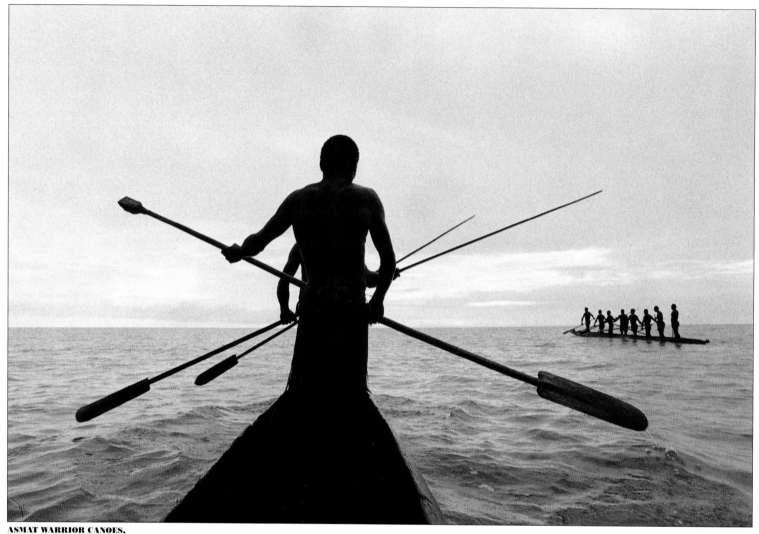

ASMAT WARRIOR CANOES.
ASMAT AREA, IRIAN JAYA, 1995

CHRIS RAINIER

A photojournalist with a special interest in vanishing cultures, Rainier has traveled around the world, spending months in places few outsiders ever see. "I like to get below the surface, to the essence of the culture and place, to capture the

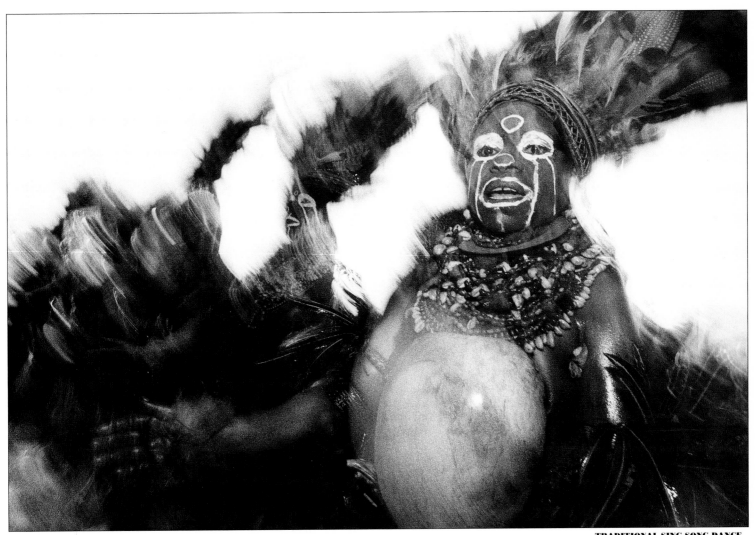

spiritual presence of a people," he says. While taking pictures in New Guinea for his most recent book, *Where Masks Still Dance*, Rainier was privileged to witness women dancing at a pre-wedding celebration *(right)*. He likes the photograph of the canoes for its stillness and for its implicit meaning. "It has a foreboding quality, a feeling of impending disaster," he says, "which, sadly, foreshadows the fate of most indigenous cultures."

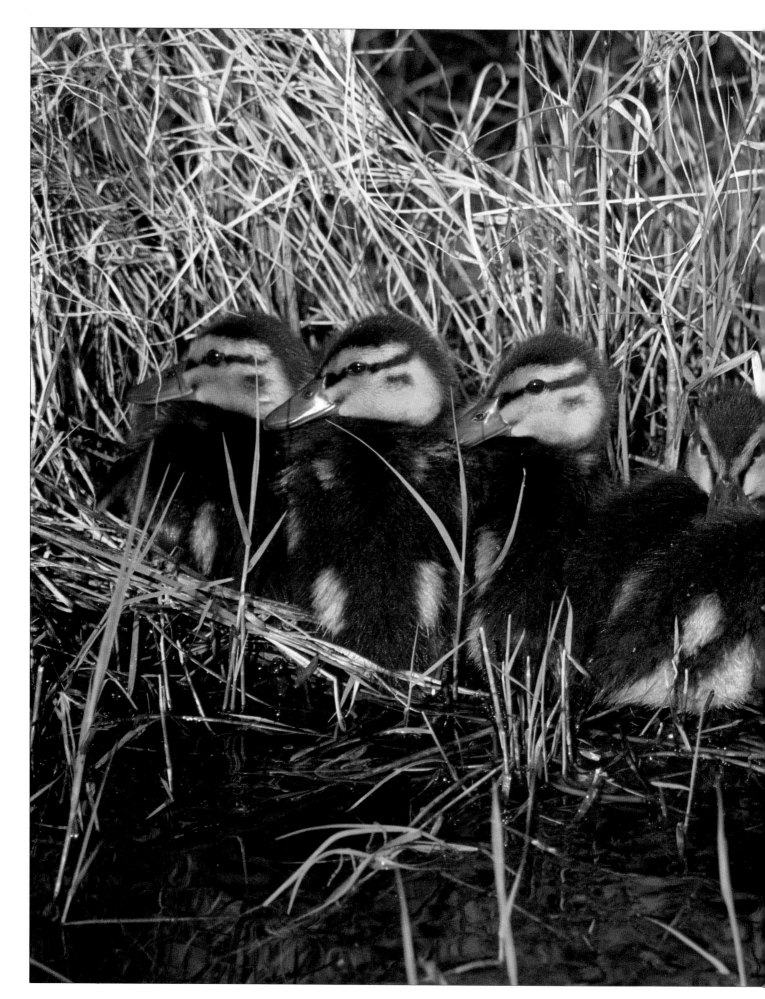

ARTHUR MORRIS

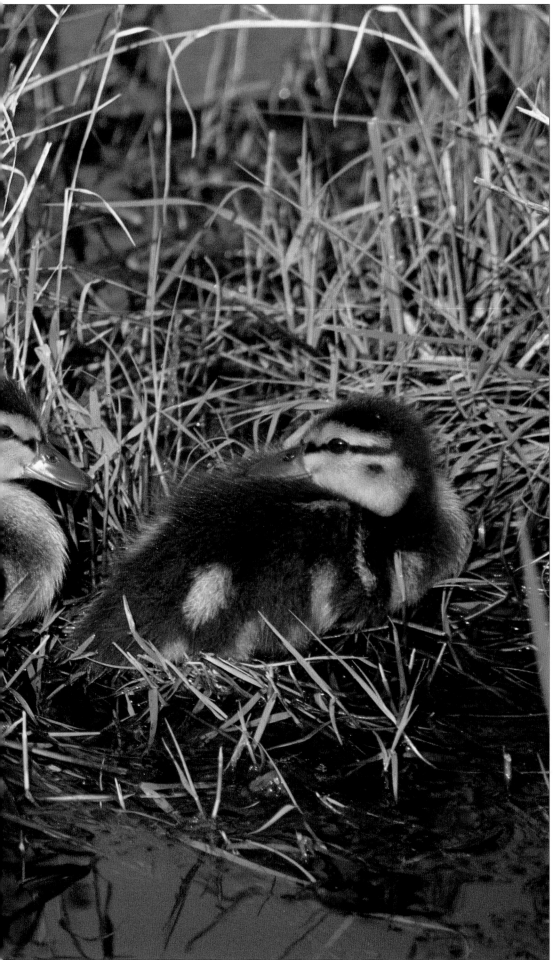

"Ninety percent of my photographs are of birds, nine percent of people watching birds and one percent of the rest of the world—I try to avoid it," says Morris, whose credit line, Birds As Art, appears on thousands of field guide and magazine pages. The Florida-based bird-watcher was tramping through New Jersey's Cape May Migratory Bird Refuge when he came upon this brood "floatin' around with Mommy." He usually uses a long lens to capture his shy subjects, but these chicks were close. All he had to do was wait for them to line up for their portrait. "We gave 'em half a buck each," he says. "It was no problem."

MALLARD BABIES, 1995

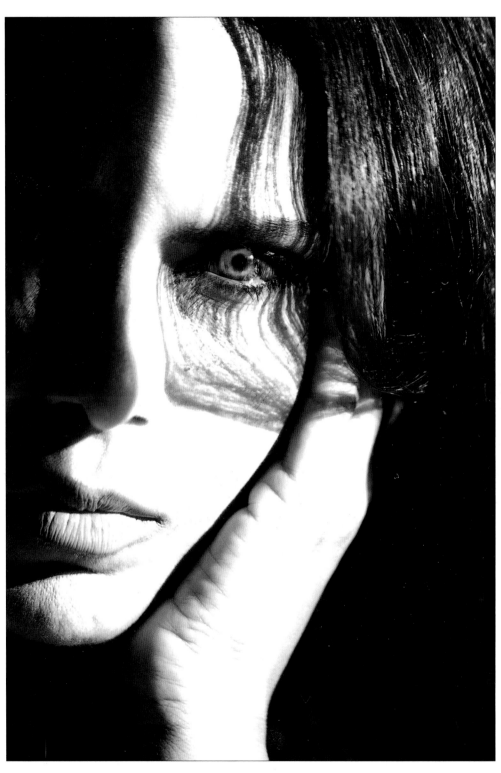

DOUGLAS KIRKLAND

The party was full of artists, but there was one guest who was a work of art. "I normally don't walk around and discover people, but this woman was so striking that everybody was stunned," says Kirkland, who asked if he could photograph her. As an apprentice to Irving Penn in the late '50s, Kirkland began as a photojournalist, making a reputation as a photographer of celebrities, especially beautiful women. His commercial work is eclectic, and his personal work evolves. "It's critical to keep stretching, if you want to keep your passion," he says. Adlin had heard of his book project *Body Stories,* and agreed to pose nude. "I thought I'd have difficulty getting models, but people just lined up around the block. They saw what I was doing and wanted to be part of it."

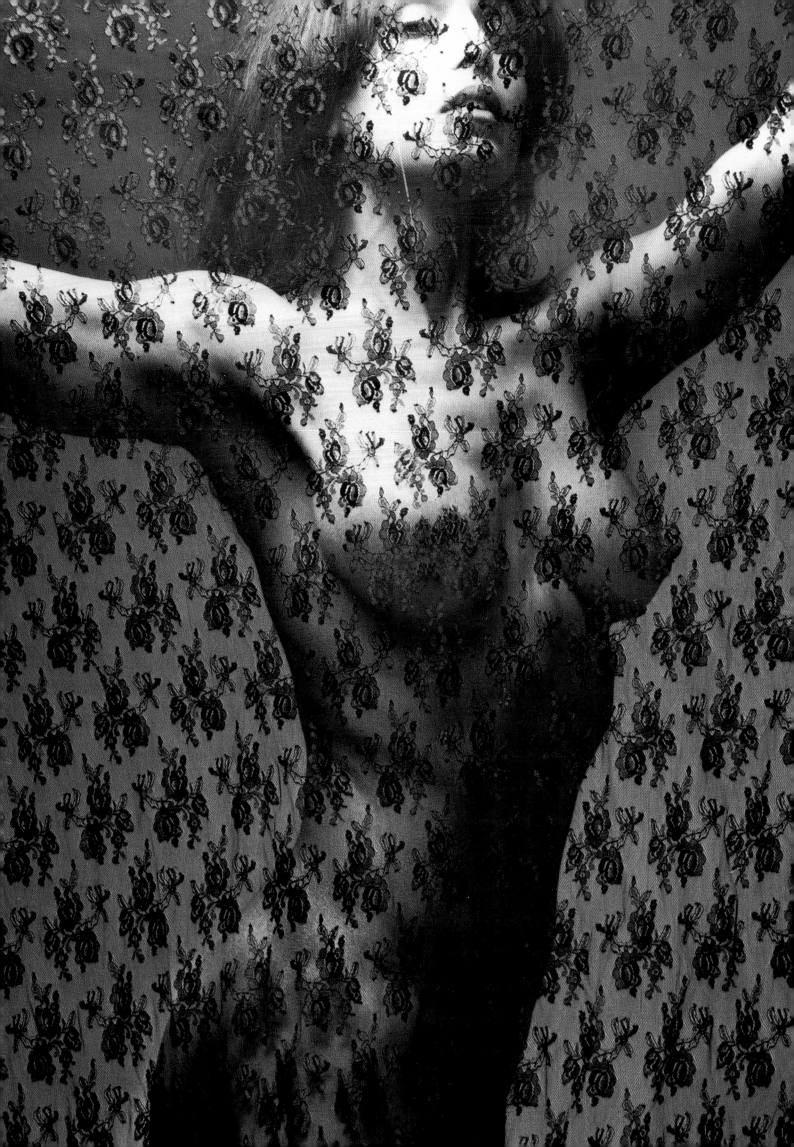

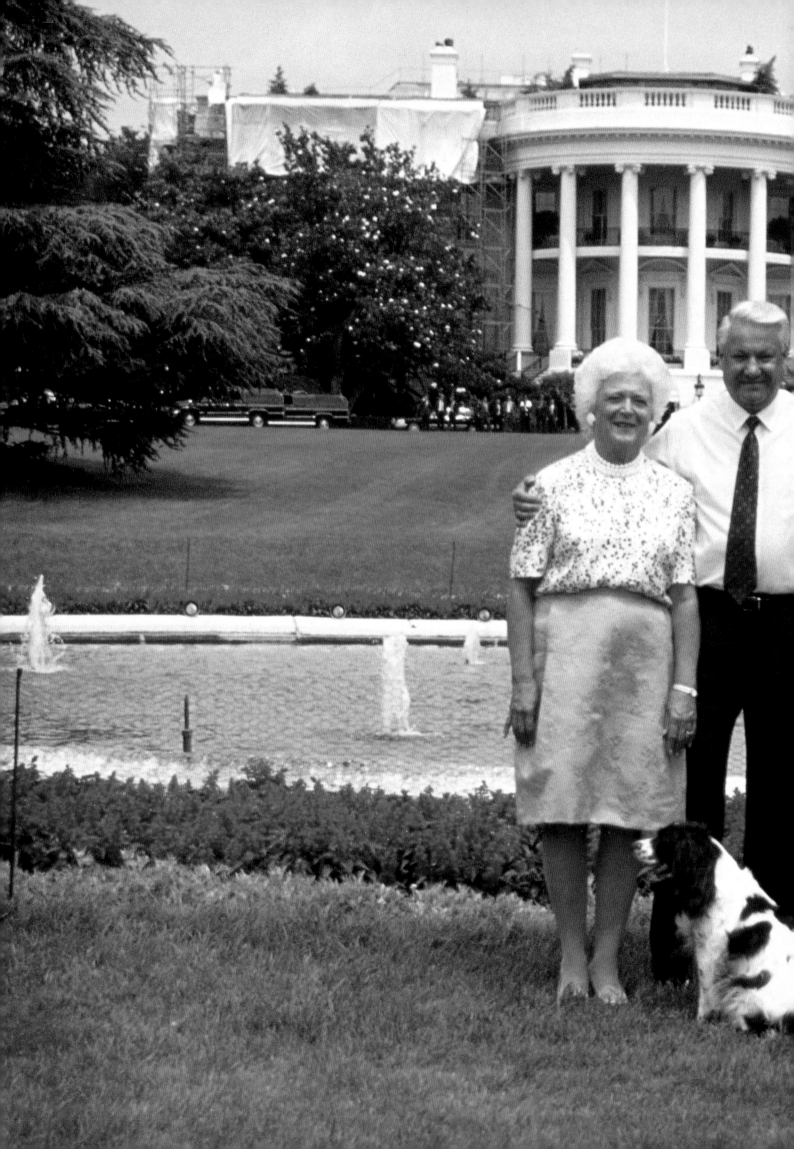

DIRCK HALSTEAD

"I am a student of the presidency," says Halstead, who has been *Time* magazine's White House photographer since the Nixon era. "I am fascinated by how each president has his effect on the Oval Office and, in turn, is changed by it." On this occasion, George and Barbara Bush and Russian leader Boris Yeltsin had been shaking hands with people through the fence on the White House south lawn. As they (and Millie) headed back, the president turned and said, "Dirck, take our picture." He took this award-winning frame. "It's the ultimate 'happy snap,'" says Halstead. "They're like any other family with a houseguest. It is a classic George Bush moment."

**OUR FRIEND BORIS
CAME TO VISIT, 1990**

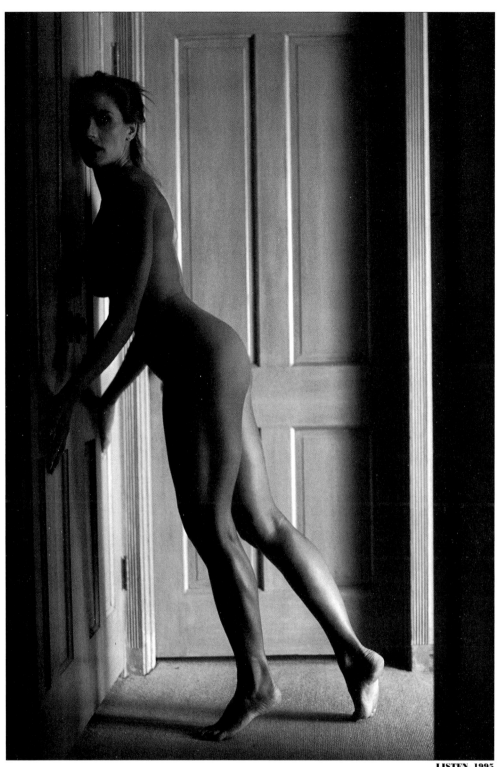

LISTEN, 1995

MELVIN SOKOLSKY

"A portrait is like a conver-
sation, it's an affinity," says
Sokolsky. "People look at
each other, have dreams
about each other, and those
dreams never, ever meet,
except in that picture."
Even in the posed world of
fashion and celebrity, he
tries to capture the inner
being without theatrical
preconceptions. "When I
listen to photographers
telling somebody to be sexy,
it makes me crazy. I don't
tell people what to feel,"
says the portraitist who is
also a film director. "For the
tear picture, it was almost
silence. The space that
we're in together makes us
both feel. One wants to show
the other who one is."

SEE, 1995

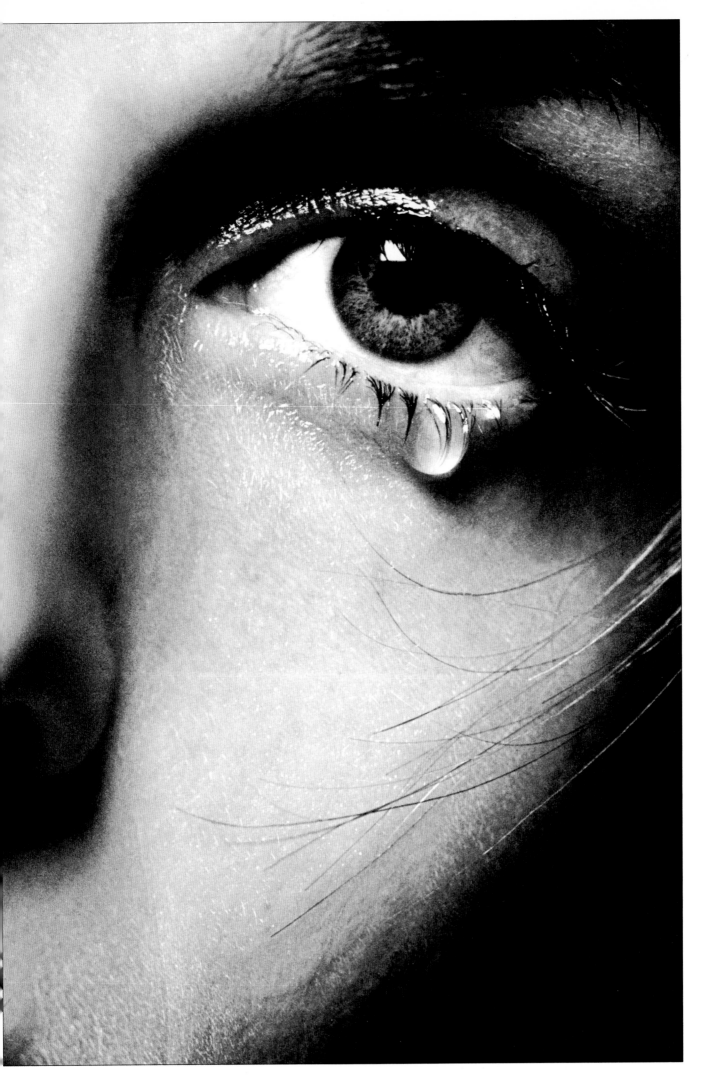

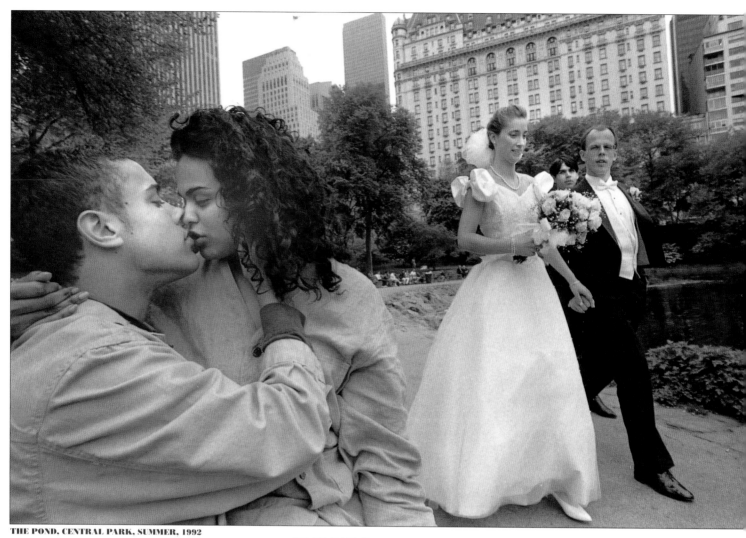

THE POND, CENTRAL PARK, SUMMER, 1992

BRUCE DAVIDSON

He enters a world and observes it for years, discovers the truths that make it what it is—a community on East 100th Street, life in the subway system, or his current project exploring the waterfront. For four years, Davidson packed

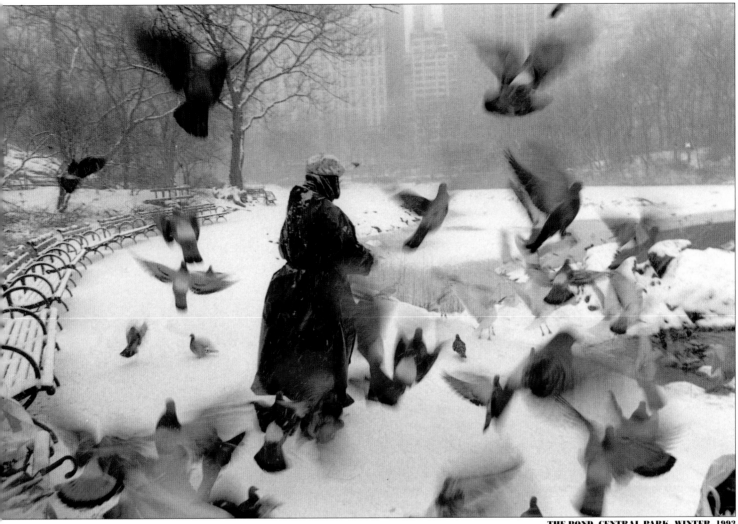

THE POND, CENTRAL PARK, WINTER, 1993

cheese sandwiches and cigarettes for the homeless, peanuts for the squirrels, bread for the ducks, bandages for emergencies, a tripod and a camera, and headed into Central Park. "I wanted to uncover the layers of meaning, the secrets of Central Park," he says, "to look at love in nature." Couples embrace, a woman dressed in a trash bag and shower cap feeds birds in a blizzard. And in the depth and detail of each frame is the city seen in tension with humanity in this diverse habitat.

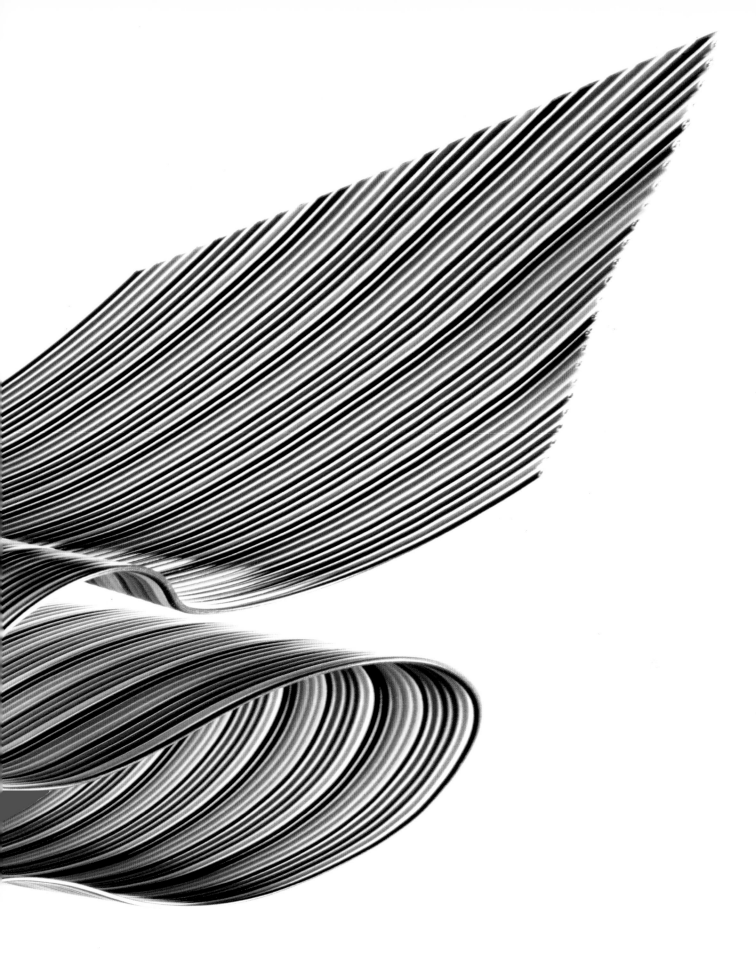

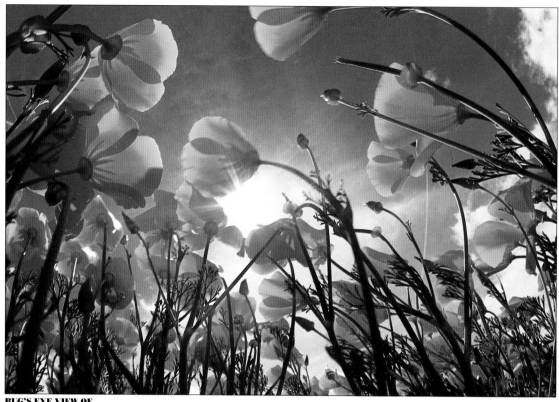

**BUG'S EYE VIEW OF
CALIFORNIA POPPIES, 1995**

GEORGE LEPP

"These two pictures represent opposite extremes," says nature photographer Lepp. "The poppies, taken with a 180-degree, 15mm fish-eye lens, and the moose in Alaska's Denali National Park with an 840mm, an angle of view of only a couple of degrees. Technically, they're as far apart as possible." The subject dictates the equipment, but Lepp's expertise—he teaches technical workshops—allows him to get pictures others might miss. As he finishes a book on poppies in Antelope Valley, California, it's been mostly micro. "I've got my nose buried in the grass, and with my hay fever, that's a love-hate relationship."

◄ **PRECEDING PAGES**

MICHEL TCHEREVKOFF

Fifteen years ago, the conceptual still-life photographer was "on press," checking one of his images being printed, when he noticed that it was also on a computer monitor. He asked about making changes on screen and found it was not only possible but the key to his future. Long a darkroom magician, he had discovered a new way to transfer effects from dreams to the printed page. For this picture, he photographed a ribbon, then used special software to clean up the background, enhance the color and warp the shape. "The arrow is a symbol of a new direction my work is taking," he says, "an evolution of the creative process. I don't care what you call it—photography, graphics, computer art. I'm an imagemaker."

**MOOSE WANDERING
DENALI TUNDRA, 1995**

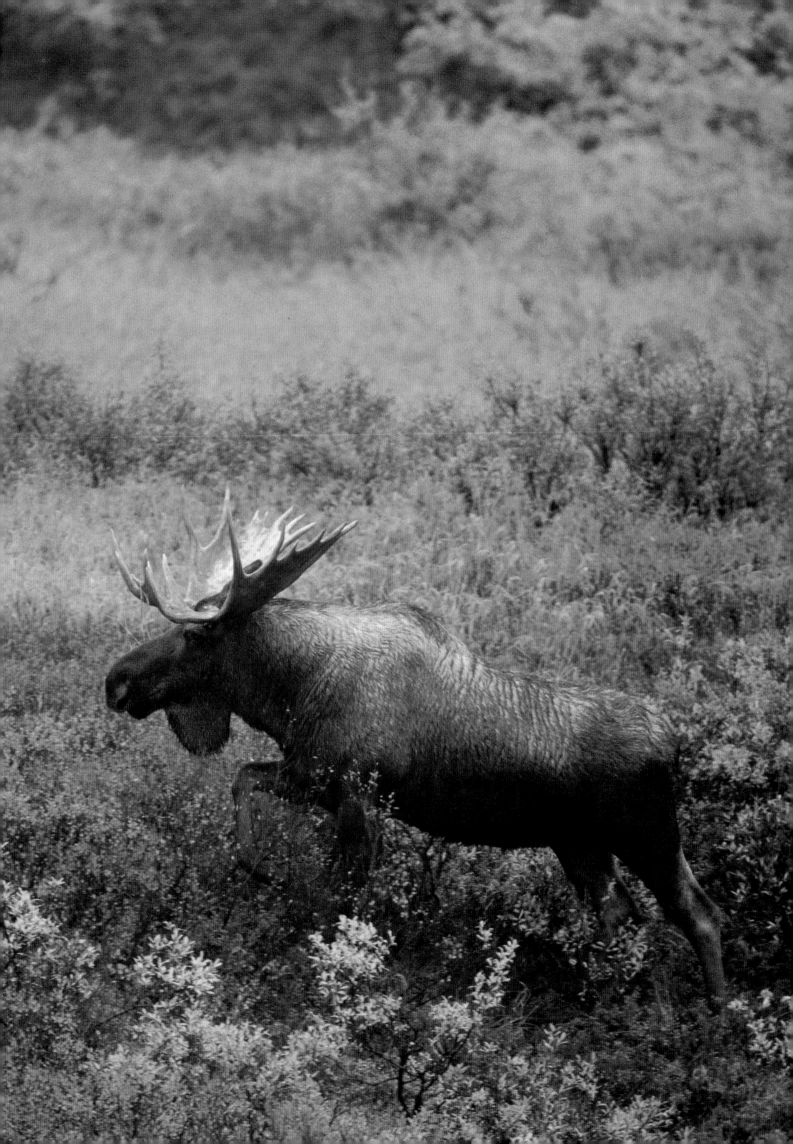

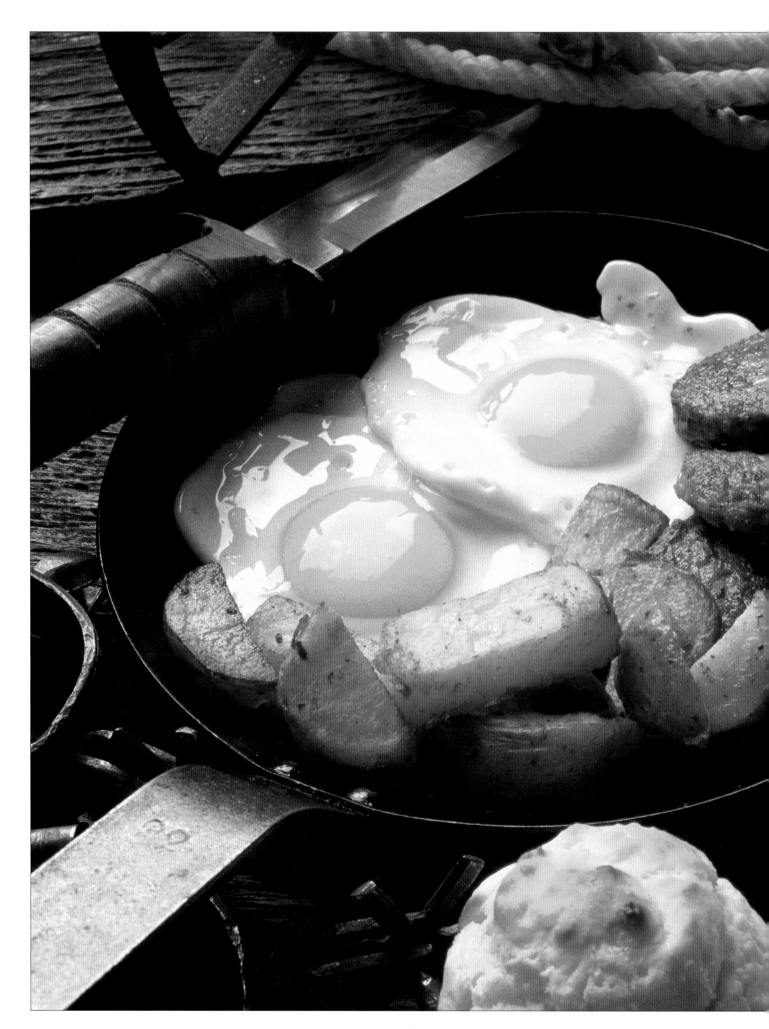

DICK FRANK

Making pictures of food is a special art—as is making food for pictures. Frank can do both. A food stylist usually preps his subjects, but he cooked this meal himself—using four dozen eggs and ten packages of sausages to get his photogenic breakfast. That was easy, he says, compared to styling lobsters (the antennae are tough) or beer (the ideal head) or ice cream—it once took him twenty quarts to get two perfect scoops that he had seconds to shoot under hot lights. These days, out-of-focus is trendy, but Frank's signature is the crystal-clear close-up: "I want in-your-face food that makes you salivate."

RANCH EGGS, 1995

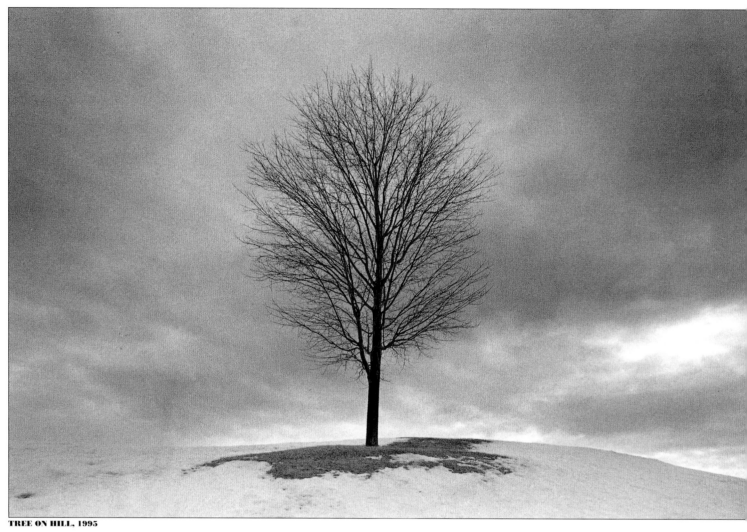

TREE ON HILL, 1995

LARRY SILVER

"I look for a graphic image with strong lines and a story-telling quality," says Silver. "I find a location that I like, and then I wait and hope for something to happen in it." For the tree that seems to be on top of the world, he had to wait for the right light. And it took four hours for this skate-boarder to happen into the frame. The two pictures have in common lots of sky and space and, he feels, a sense of isolation. He likes

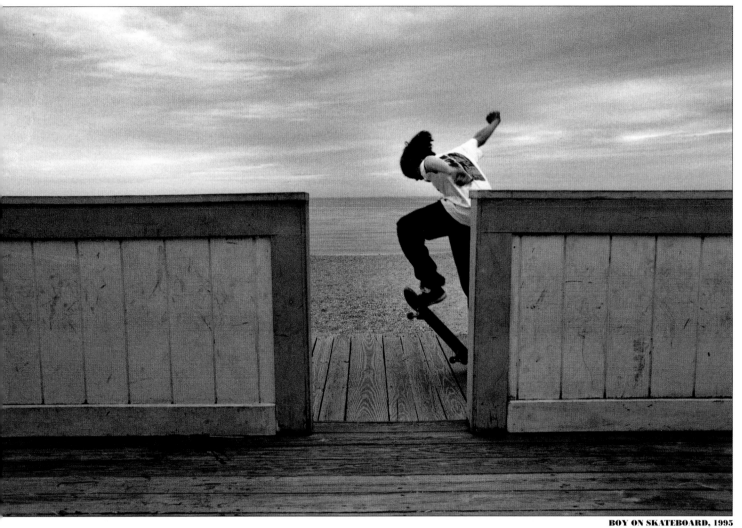

BOY ON SKATEBOARD, 1995

he light of early morning near his Westport, Connecticut, home. "It gets lonely. get a lot of jogger pictures, since nobody else is around." When he began hooting in New York City and on Muscle Beach in California in the '50s, people thought of photography as a hobby: "Passersby used to look at me like maybe next you'll be collecting butterflies—or coins." Today museums are collecting him.

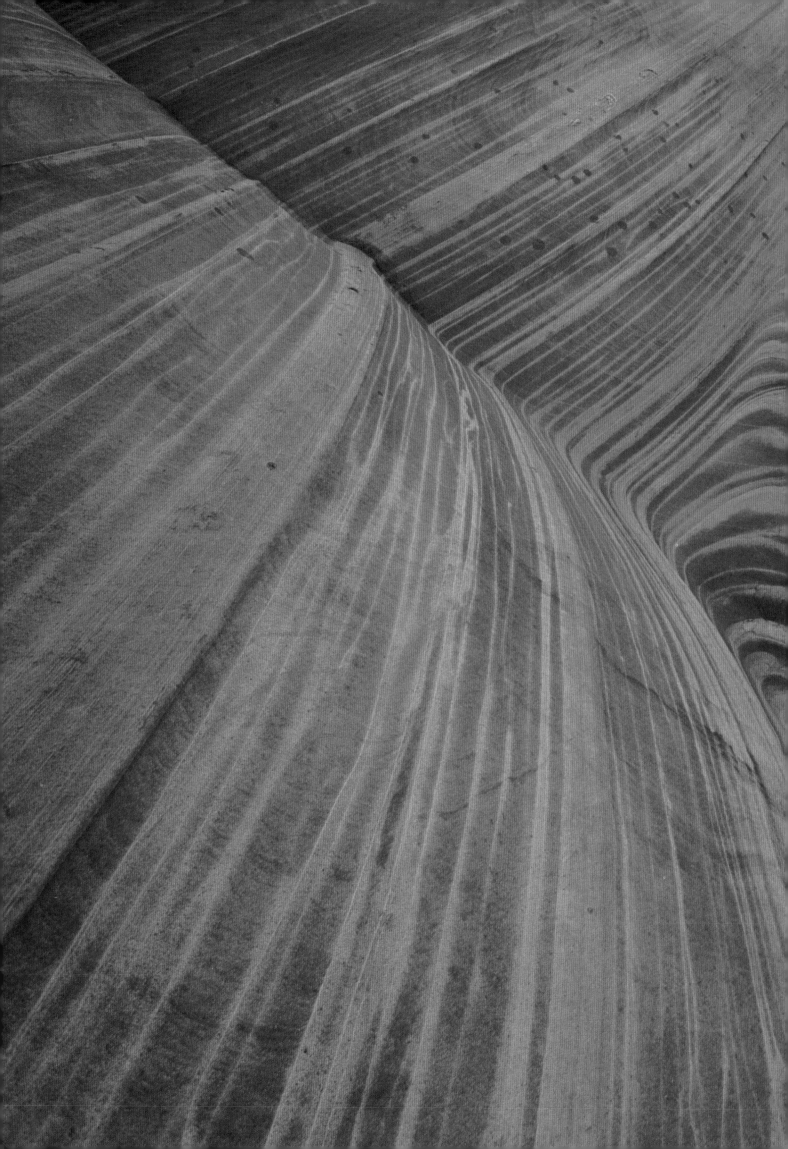

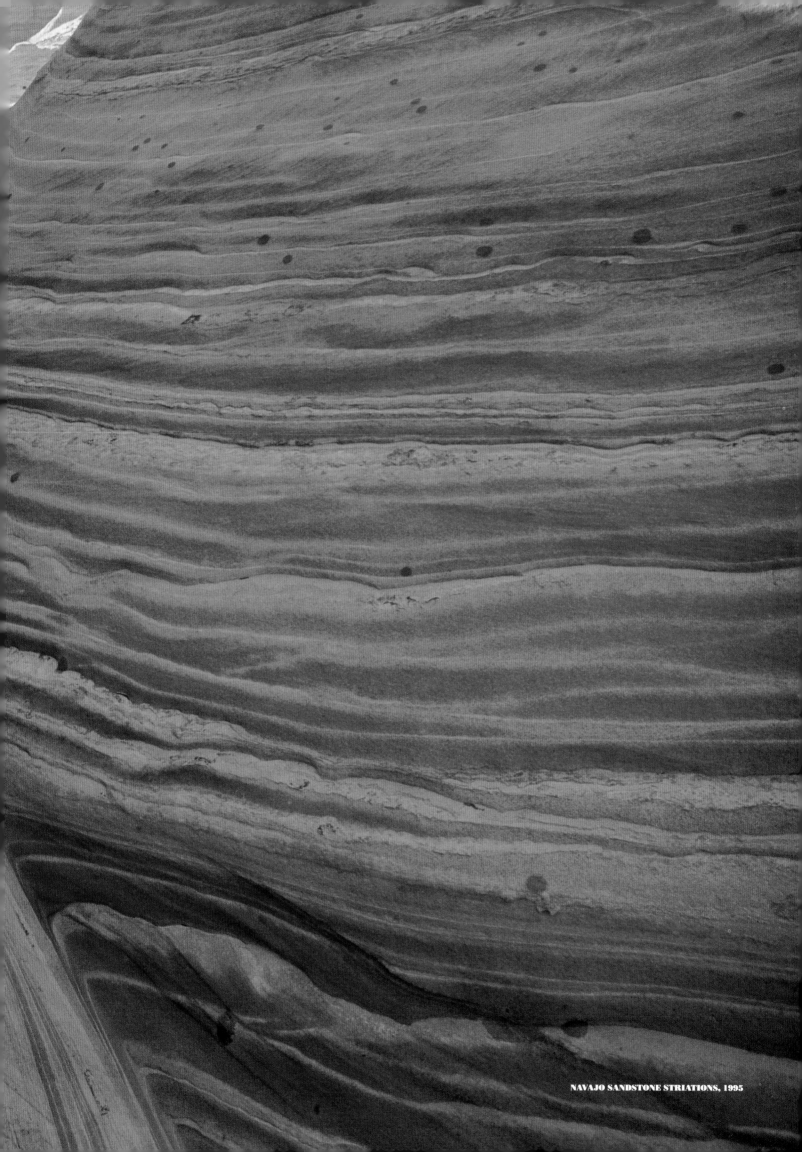

NAVAJO SANDSTONE STRIATIONS, 1995

PETER READ MILLER

"At the Olympics, you're all looking at the same stuff," says Miller, who has covered four summer games. The fact that he was unfamiliar with swimmers helped him focus on image rather than content, he says. Had the *Sports Illustrated* staffer been shooting football, his specialty, he might have followed Troy Aikman or Steve Young and missed a better picture. To get this angle in which the lane markers run together in a field of red, he lay down on the pool deck. "There's an element of luck, of planning, of technique—and how you respond to the whole thing," he says. "You try and make one that's different."

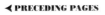
◄ PRECEDING PAGES

DAVID MUENCH

"Out with the old-world landscape—one-third land, two-thirds sky," says Muench, who has published forty books of landscapes. "I don't need skies. I like the dynamic foreground. You get right into it, really involved, and then let it flow away into the distance." He has roamed all over America, but his favorite is the Southwest desert. This photograph was made on the Utah-Arizona border. "I've never seen nature produce such abstracts," he says. Although this spot was a four-mile hike from the road, other people were also taking pictures that day: "It's being loved to death." But no one else saw it just this way.

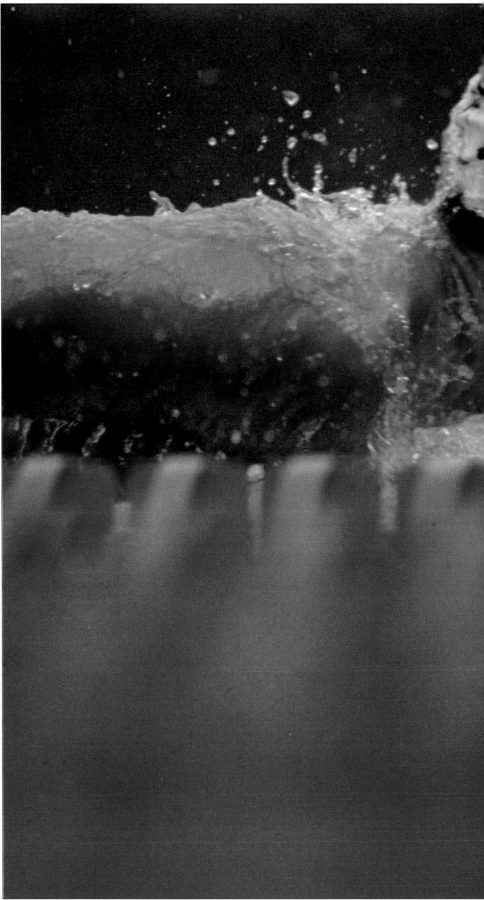
SWIMMER, BARCELONA OLYMPICS, 1992

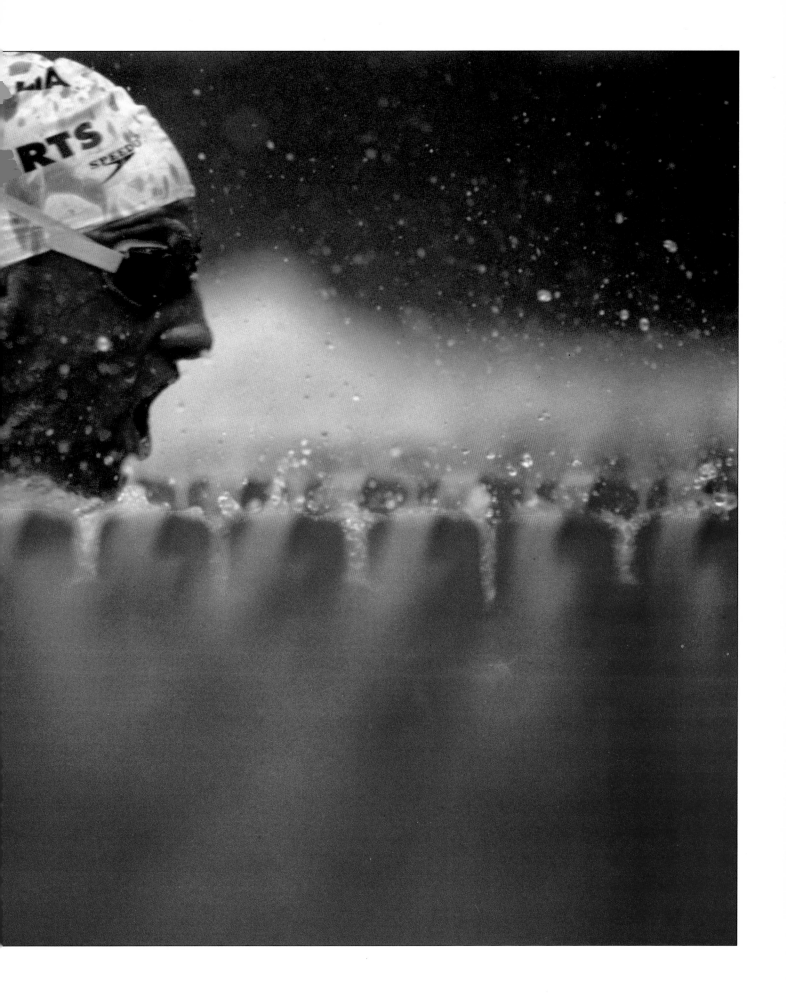

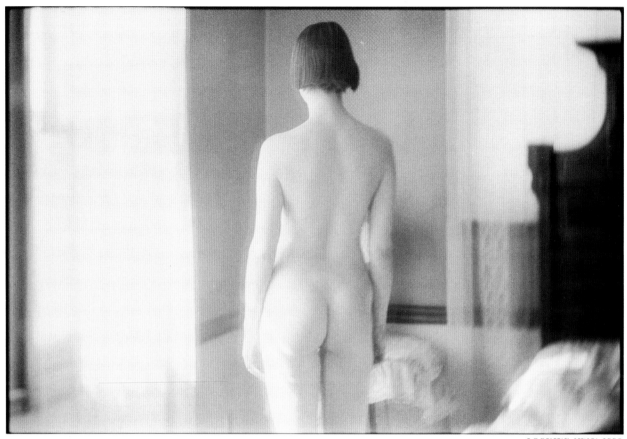

LOOKING AWAY, 1996

ROBERT FARBER

Jacqueline Kennedy Onassis's personal copy of *Farber Nudes*, inscribed to her by the photographer and retailing for about $40, fetched $4,250 at Sotheby's auction of her effects. "That's the most one of my books has ever cost," jokes Farber, whose *By the Sea*, now in paperback, was edited by the former First Lady. These recent photographs were made of one model at the same time. "I try to bring a sensitivity to my images, to show respect for my models," says Farber, who shoots fashion and beauty as well. For these pictures, he used available, household light, throwing the focus out a little bit to conceal the details of the face. "I like a soft, romantic look," he says. "You don't relate to her as a particular person. It keeps the mystique." Something Jackie, too, understood.

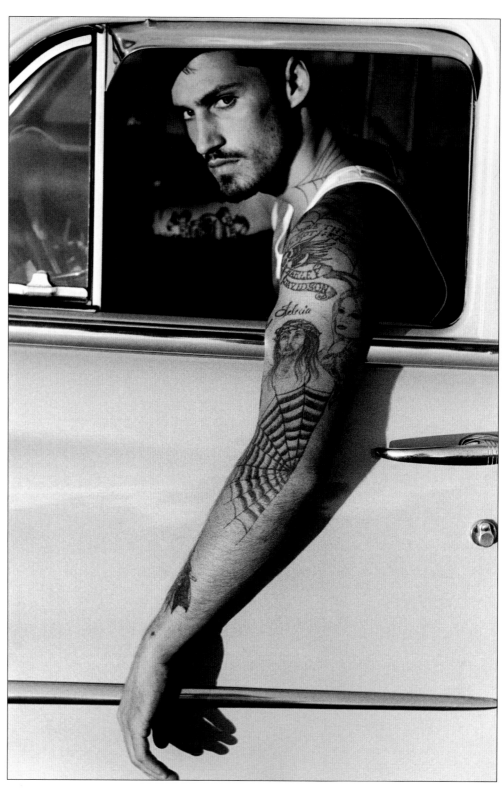

ALBERT WATSON

The man above is a prisoner at Louisiana State Penitentiary, the other a world champion boxer. Yet through Watson's lens, both the unknown and the renowned are heavies, observed with equal weight, whether rebuilding a car in a prison body shop or winning in a final round. Born in Scotland, Watson is now based in New York City. His exhibitions travel the world, as does the photographer himself. He has directed music videos for the likes of Sade and Morrissey and is in a position to appreciate the ups and downs of transient fortune. After all, Watson was the official photographer at the wedding of Britain's Prince Andrew and Sarah Ferguson. *Tempus fugit.*

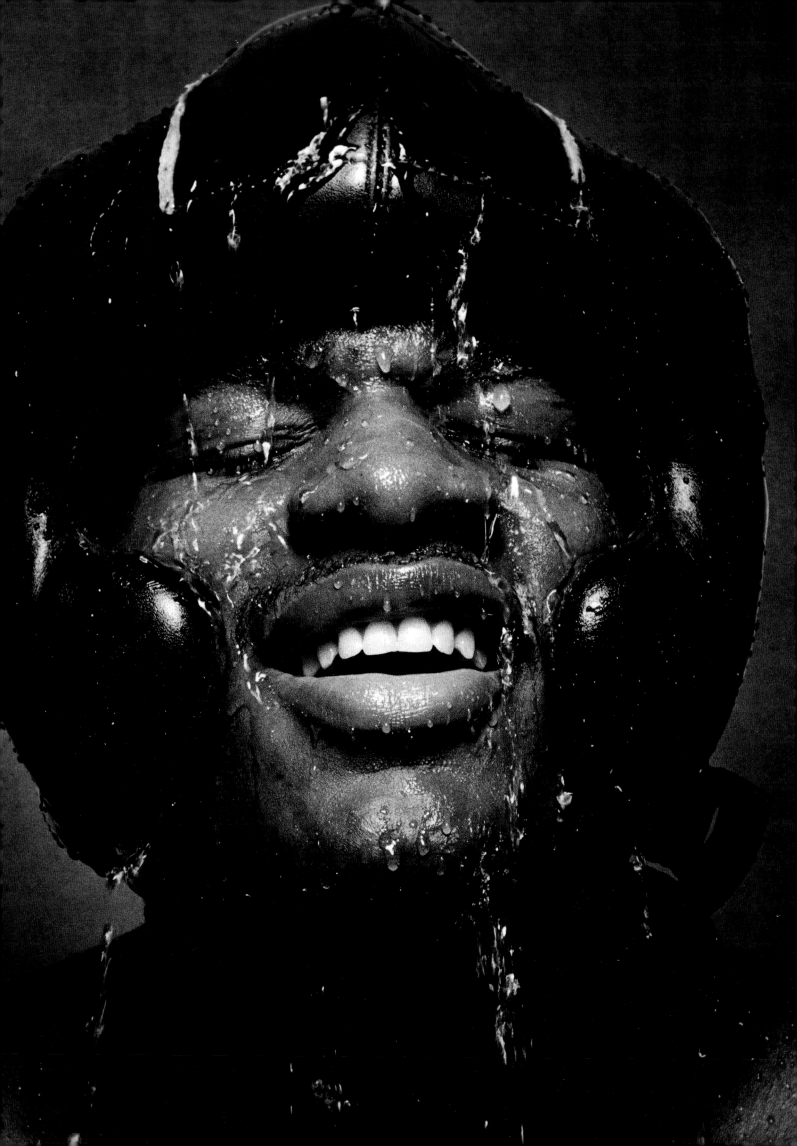

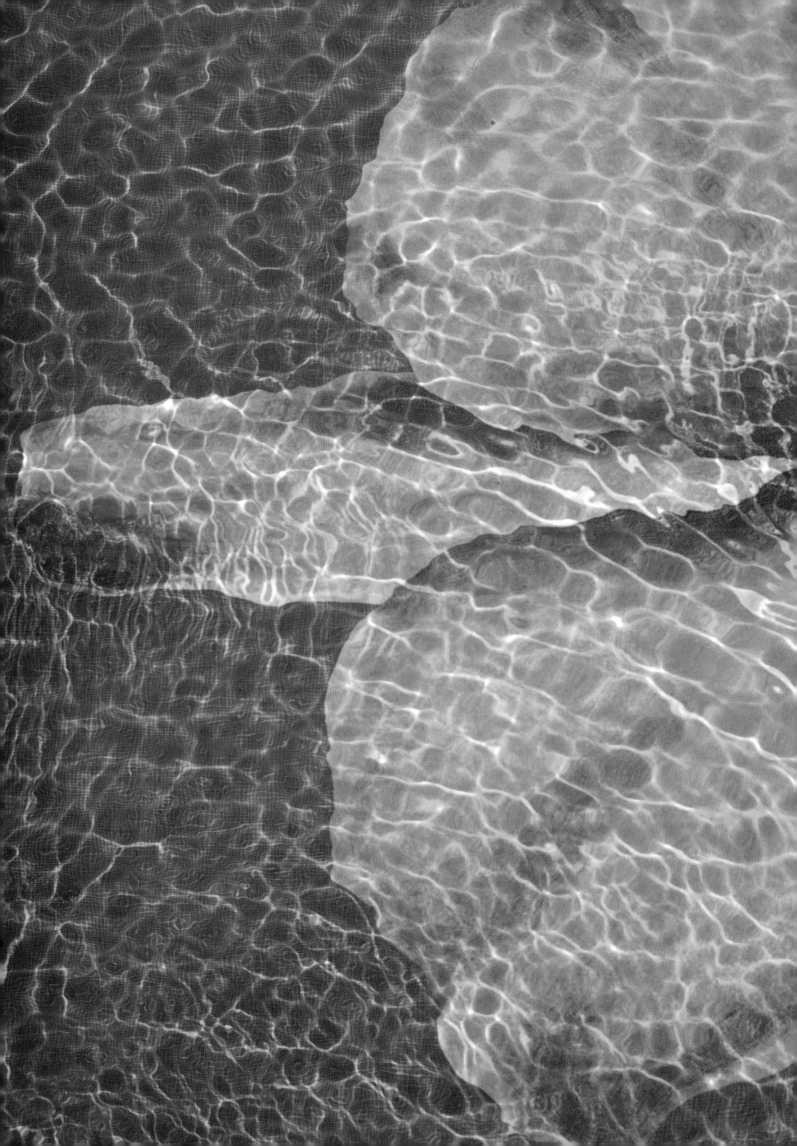

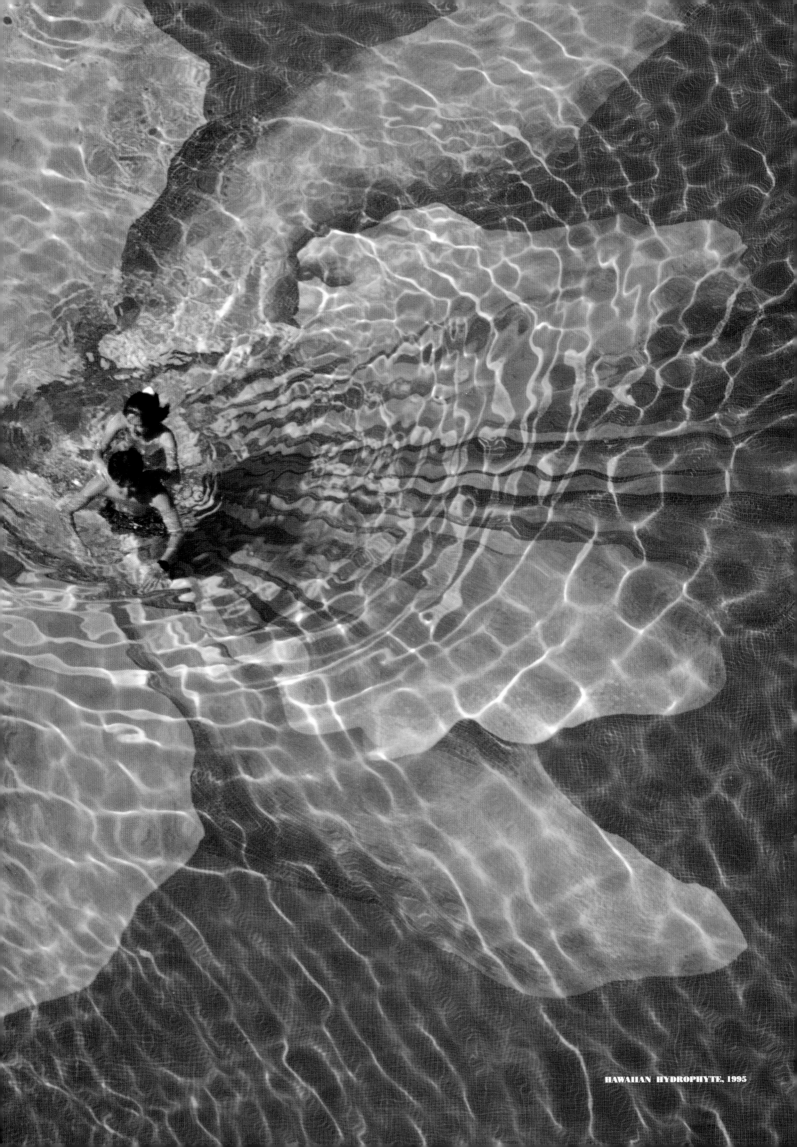

HAWAIIAN HYDROPHYTE, 1995

JACK REZNICKI

HUNTER, 1995

"Shooting kids is like a greased pig contest. Just when you think they're zigging, they zag," says Reznicki. "The serendipity of it takes you to a place you weren't expecting." The virtue of this picture of Hunter is its simplicity. "It caught the little gleam in his eye—everybody knows a kid like that," he says. The boy with the violin is a more technically mannered picture, with the point of focus on the child model's face. "Even professional kids are kids first," says Reznicki. "To get a good photograph, you have to make it an enjoyable experience for them."

◄ **PRECEDING PAGES**

NORMAN McGRATH

Looking down from a balcony thirty stories above Honolulu's Waikiki Beach, a casual observer could see surfers in the waves, a cruise ship passing. McGrath saw a swimming pool with a design of a submerged flower. "My work is seeing things that other people miss," he says. By profession he makes architectural photographs, a carefully designed art. When he shoots for himself, he likes to have "the freedom to react, unfettered." When this couple swam into the center of the flower, rippling the water geometrically, he clicked the shutter. Their isolation in the frame, he says, makes the composition almost an abstract. "I like to disorient viewers," he says. "Make them stop and look again."

DONALD WITH VIOLIN, 1995

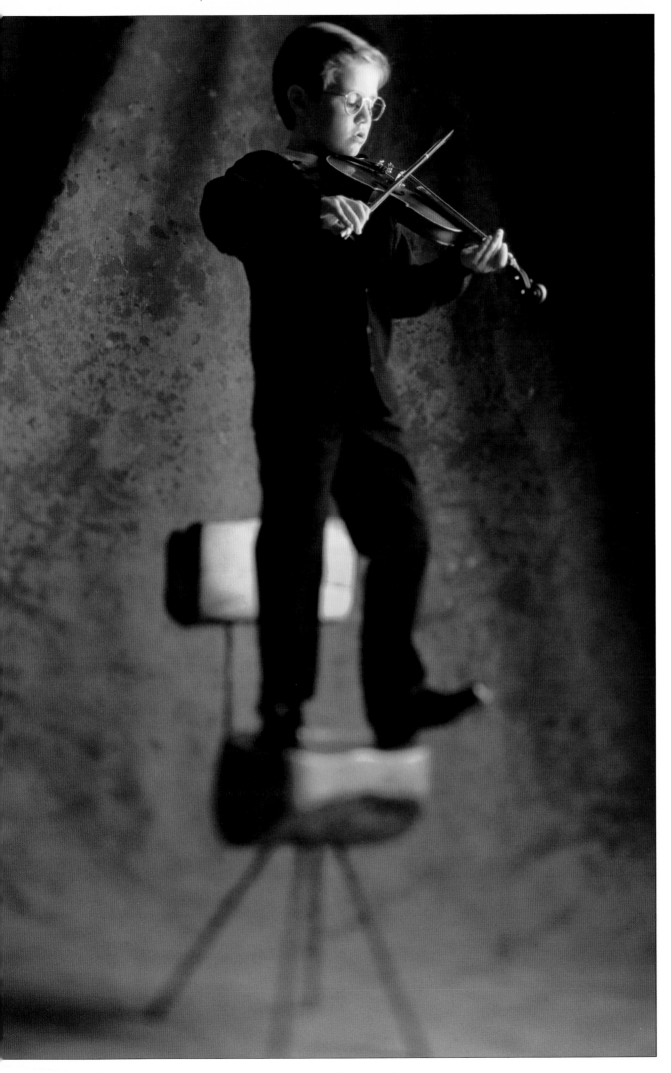

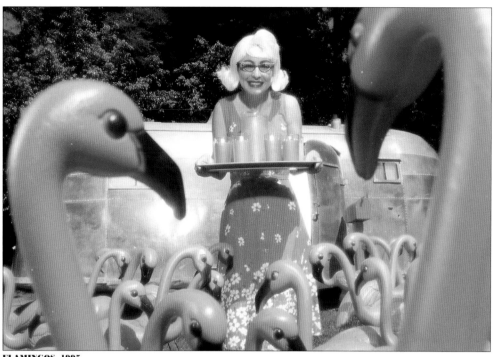

FLAMINGOS, 1995

NEWSSTAND, 1995

JAMES WOOD

"I create everything inside my head, then make it on the outside," says Wood. "I don't ever trust to just finding something." These "minute cliff-hangers" were shot on the same day on the Warner Bros. lot near his home in Los Angeles. He bought the flamingos, the wig, rented the dress, hired an actress and trucked in the mobile home. The newsstand was rented from a prop shop and set up on a city street set. "It's a lonely, Hopperesque moment in a newsman's life, a nonevent," he says. "I want the viewer to wonder what the hell is going on here." He paints abstracts on canvas, but draws, he says, with the camera, a quiet, grainy, stylized, impressionistic look. "Not brutal," he says. "Dreamlike, like these."

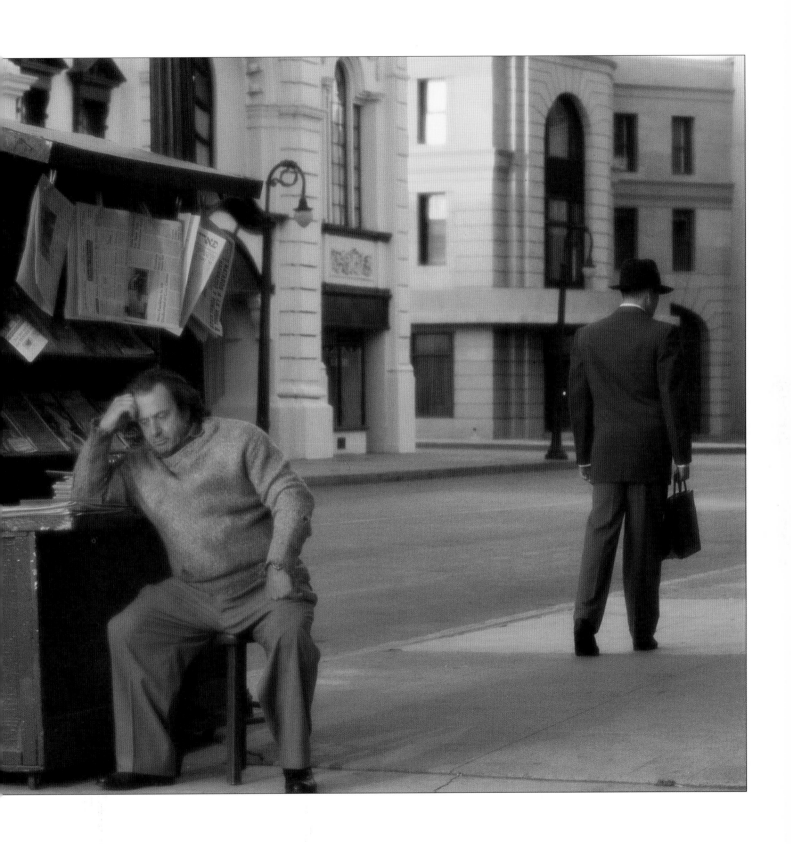

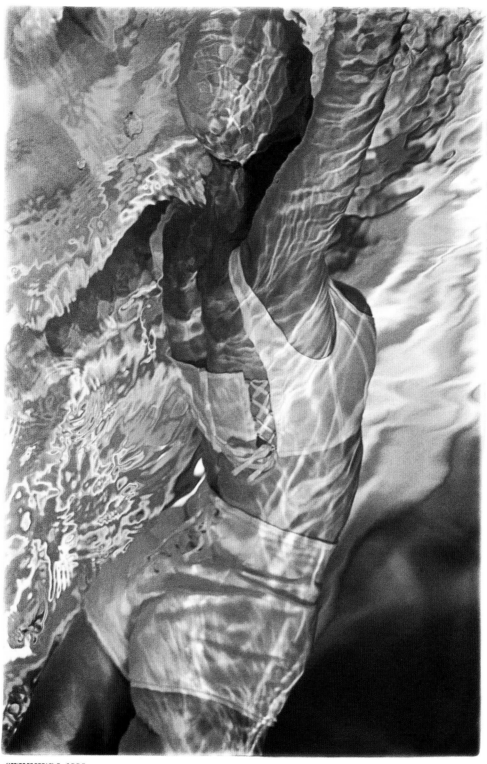

SWIMMING I, 1996

SARAH MOON

"I photograph privilege, illusion, evanescence, unlikeliness," says Moon of her dreamlike images. "I watch for what I don't expect." A director of commercials and film (she recently did a documentary on Henri Cartier-Bresson and the Lumière brothers), the Paris-based Moon got her first taste of photography on the other side of the camera, as a model. She began taking pictures of her peers and became famous for her fashion photography. These images were part of an assignment on bathing suits for *Marie Claire Bis*. They were taken on location, in motion, rather than in her studio. "For a split second, I see a sparkle of beauty passing by," she says. "I look for an image that surprises me and yet I recognize—voilà!"

SWIMMING II, 1996

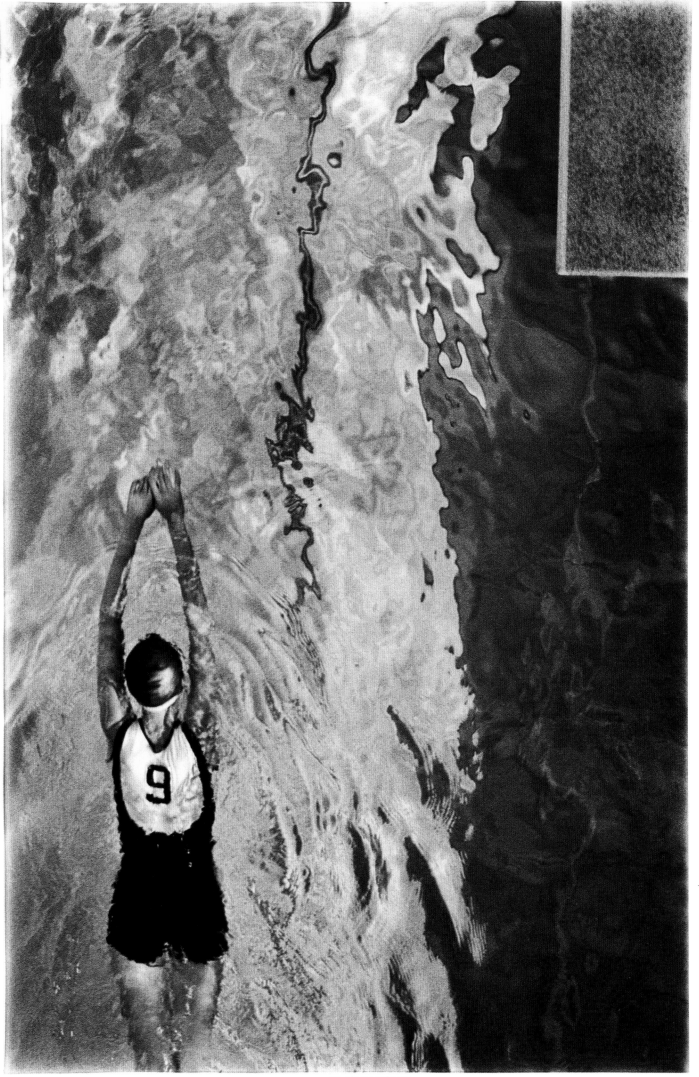

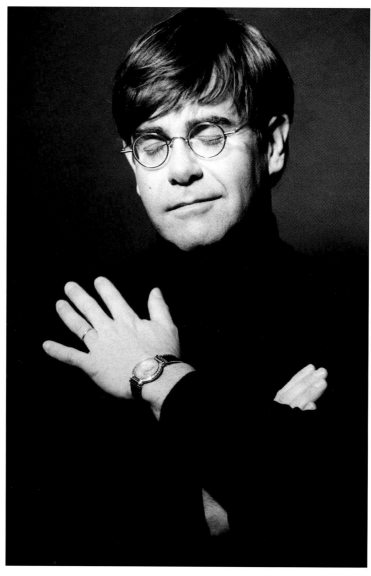

ELTON JOHN, 1994

GREG GORMAN

Ever since the '60s, when he began taking portraits of rock and roll bands, Gorman has been refining his skills as a celebrity portraitist, having memorable sessions with the likes of David Bowie, Sophia Loren, Marlon Brando, Bette Davis and Keanu Reeves. He branched out into music video direction and film publicity for such movies as *Tootsie, Speed* and *Escape from L.A.* His portraits are known for their starkness and simplicity. Always, he waits for a moment. "With Leonardo, it was the moment when his eyes came into the lens," says Gorman. "And with Elton, when he touched his heart." Gorman, a consummate host and cook with a 3,000-bottle wine cellar, likes to create real life moments as well. At one recent brunch he introduced old-school actress Gina Lollobrigida to enfant terrible auteur John Waters. "They got along great," he reports. "Nice people who would never get a chance to meet in real life." The rest of us will have to be content to meet them through his lens.

LEONARDO DI CAPRIO, 1994

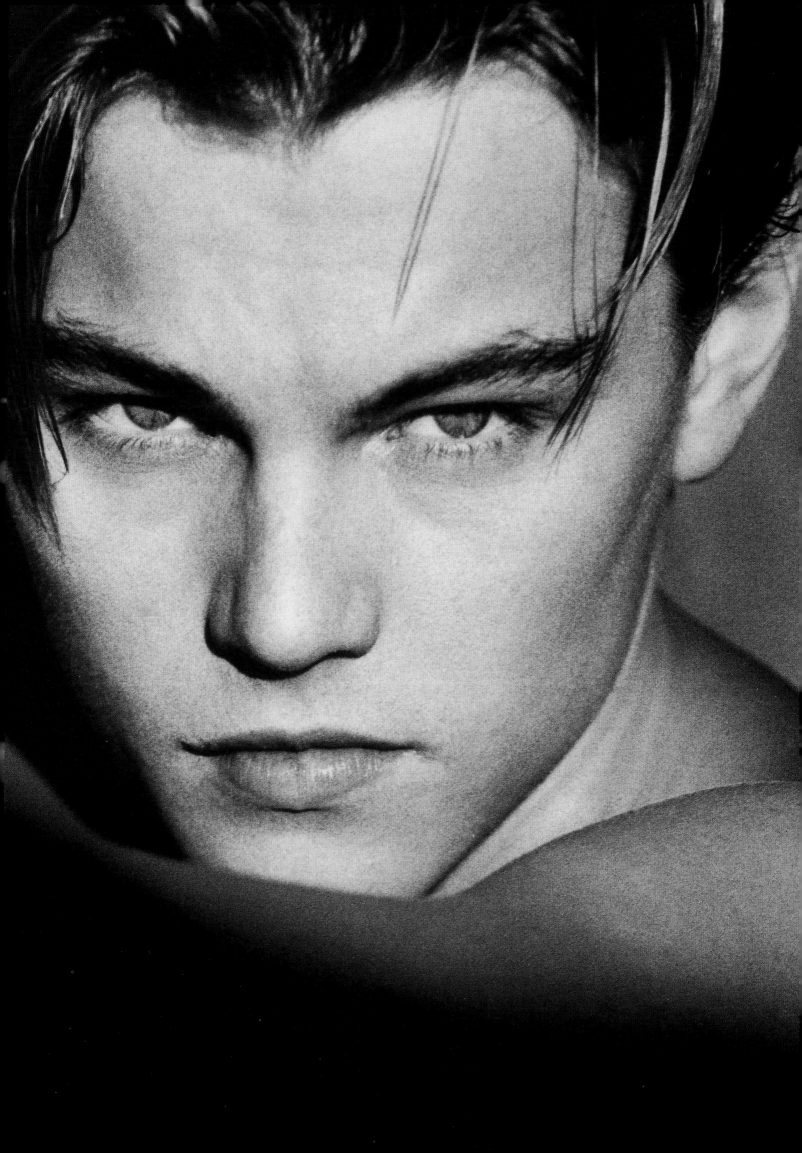

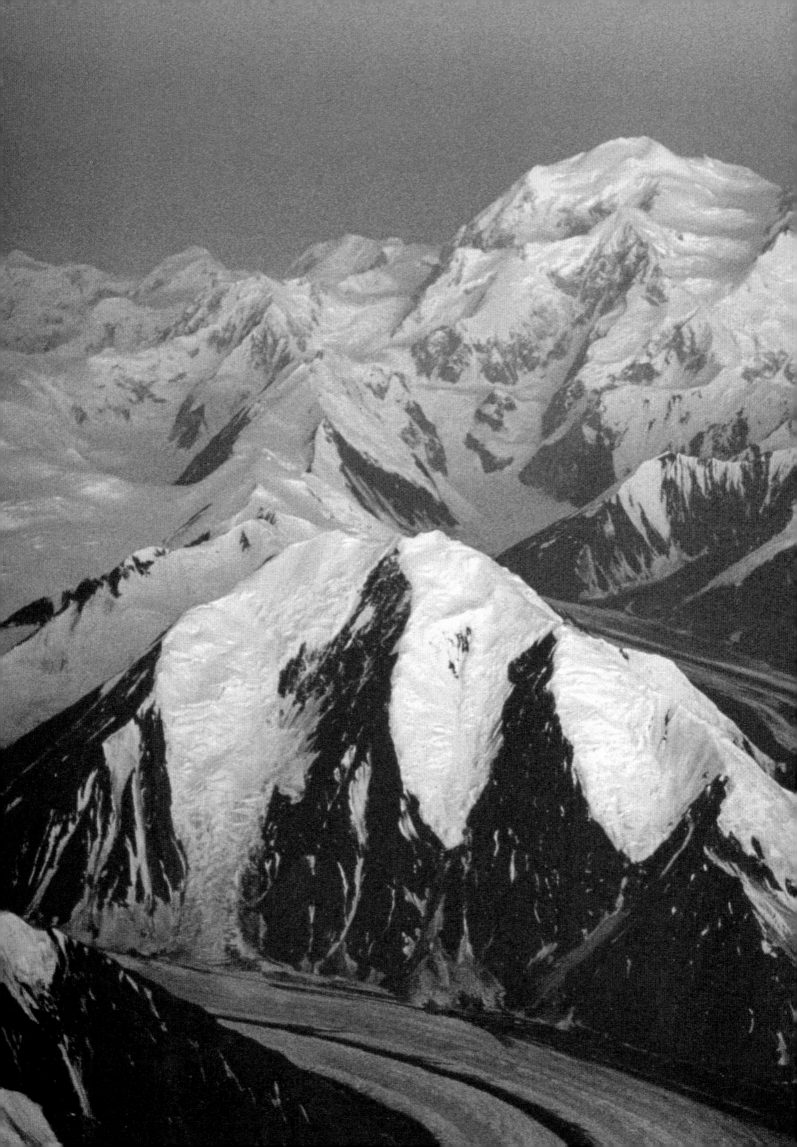

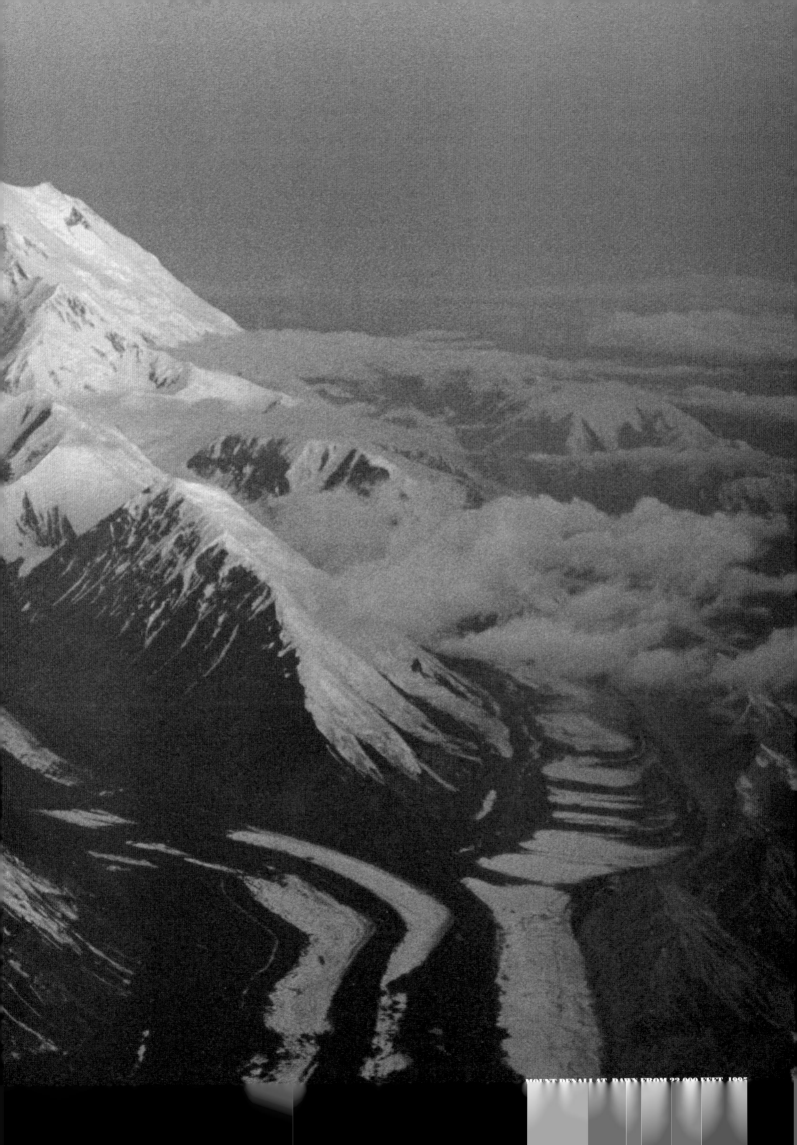

PAUL BOWEN

"I've seen many more sunrises than I ever wanted to," says Bowen, who shoots at daybreak or dusk. He probably would never have specialized in aviation photography had he not moved to Wichita, Kansas, the headquarters of airplane manufacturers like Beech, Learjet and Cessna. After a year directing a halfway house, Bowen started out as a photo assistant. Now he's up in the air early and late, with more than 350 flying magazine covers to his credit. Wearing fingerless gloves against the chill over the Channel Islands off Santa Barbara, California, he perched in the tail gunner position of a B-25 bomber at sunset. Using hand signals to direct the Hawker's pilot, Bowen made this rare picture showing the swirls of wingtip vortices. Despite the dangers of such air-to-air duets, Bowen plans to see many more sunrises—and many more sunsets.

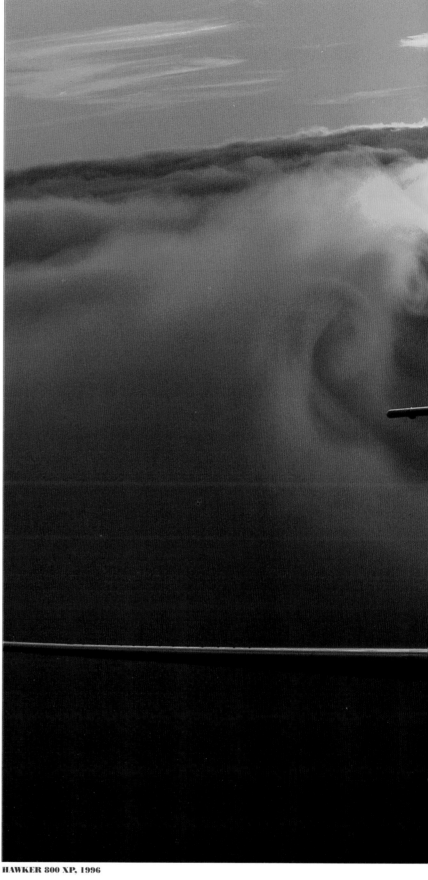

HAWKER 800 XP, 1996

◀ **PRECEDING PAGES**

HARVEY LLOYD

"Everybody has a soul that wants to fly," says the aerial adventure-travel photographer. "You get to see things that only the gods usually see—Mother Earth's bones." One such sight was Alaska's Mount Denali at three a.m. and 40 degrees below zero from a Cessna 210's open window. Pilot and photographer had to use oxygen. Lloyd has traveled more than 1.5 million air miles, making pictures of ships at sea and, for the recent book *Sacred Lands of the Southwest,* of the landforms of the Colorado Plateau. "Photography is about rediscovering your vision. I'm relearning how to see as a child sees, like Picasso," he says. "Making love is instinctive; learning how to see is hard work." But it has been a grand voyage of discovery. "The world is my studio and my university," he says. "I'm really in the catbird seat."

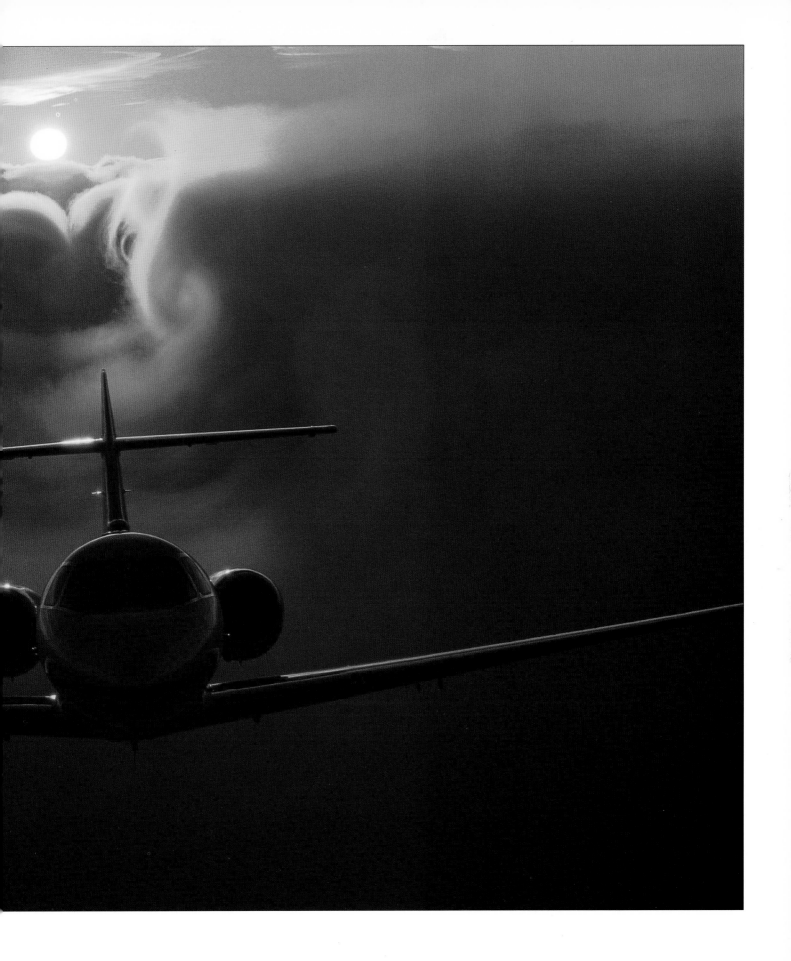

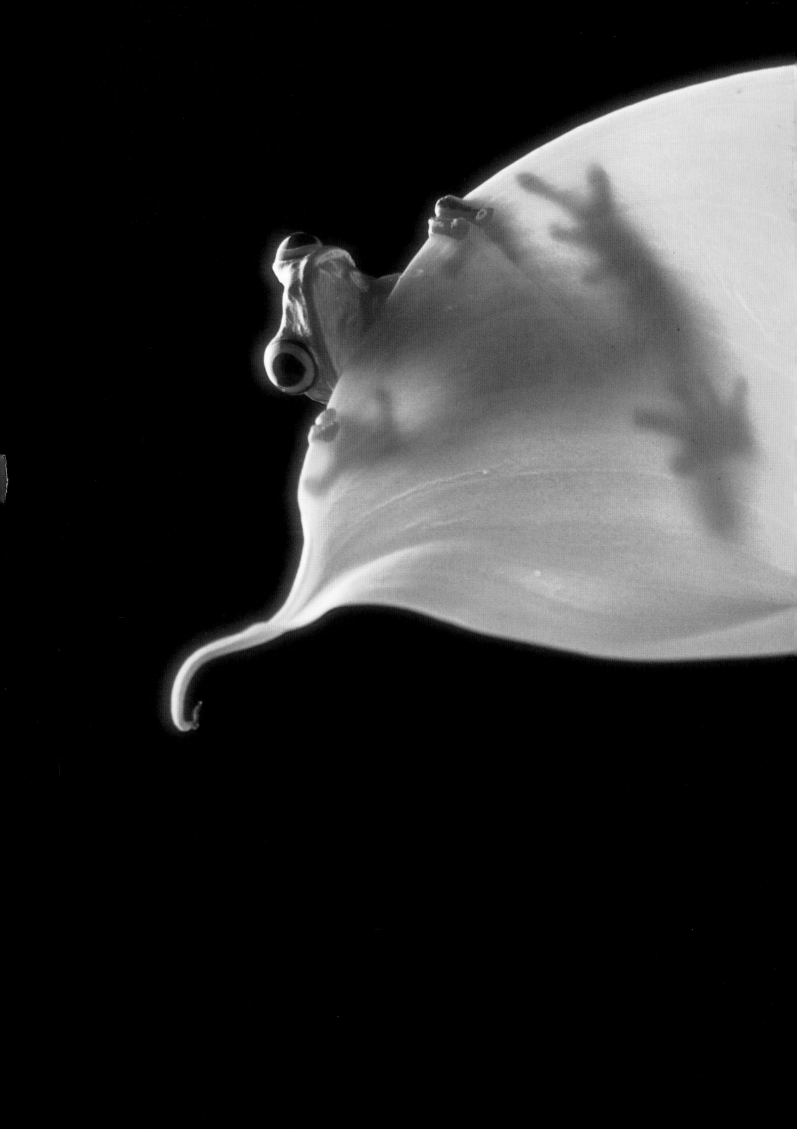

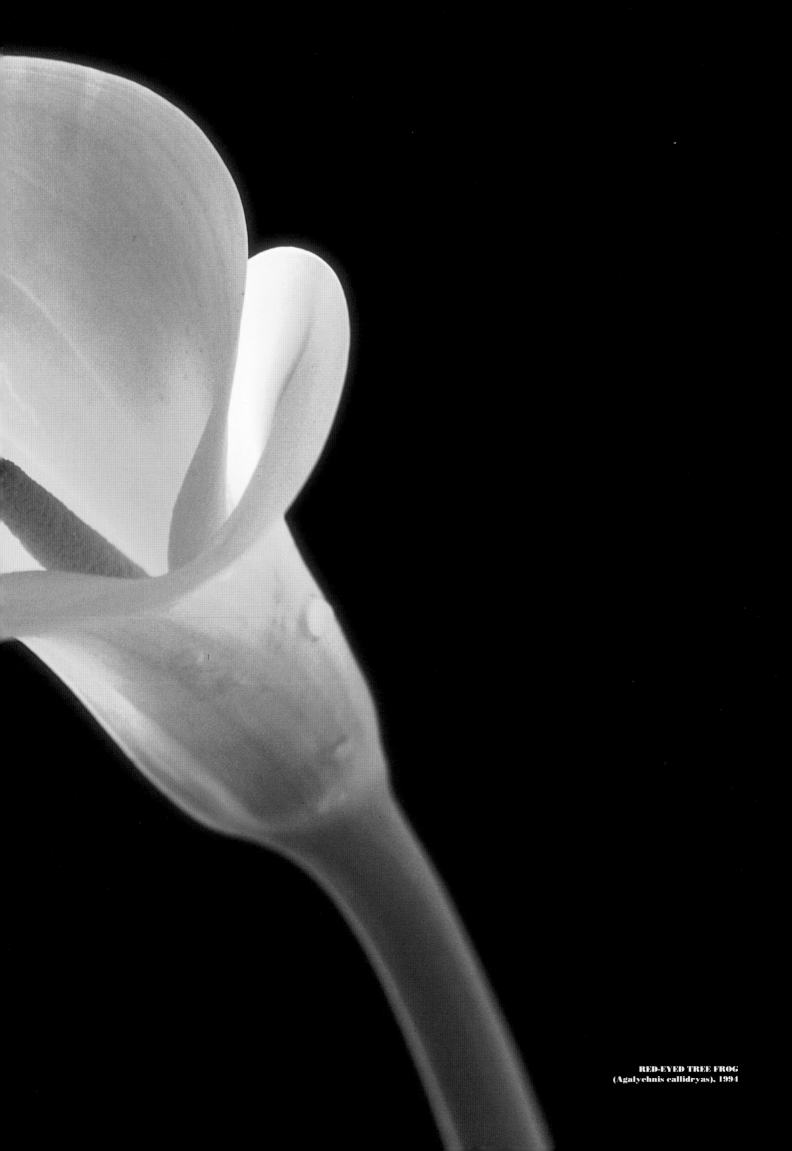

RED-EYED TREE FROG
(*Agalychnis callidryas*), 1994

STEVE KRONGARD

"It was a great-looking blizzard," says Krongard of the January snowstorm that stopped New York City. On assignment, he takes pictures of everything from landscapes to airplanes to people in offices, but this white evening he was on his own. "I went exploring, trying to keep my film and cameras dry and looking for signs of life. I saw the red neon." He waited around for a photograph to happen, until these passersby were attracted by the light. Then Krongard did what he likes to do: intensify the scene. "I'm attracted to strong color and shapes," he says. "You look at a sunset or a flower and are moved by the beauty and color. I make it just a little richer, exaggerate the reality of what I see."

◀ PRECEDING PAGES

BRIAN LANKER

"My work is always taking twists and turns, from shooting swimsuits for *Sports Illustrated* to cowboy iconography for advertisers to black-and-white portraits of great African-American women," says Lanker. "I don't normally photograph frogs." Visiting a friend's amphibian breeding project, Lanker used the occasion to test the limits of his equipment. Fascinated by the tree frog's colors, he posed his subject with different flowers, like this calla lily, looking for fine detail and saturated color. "It's another strange capillary off the main artery of my work," he says of the leaps he takes. "I'm never bored."

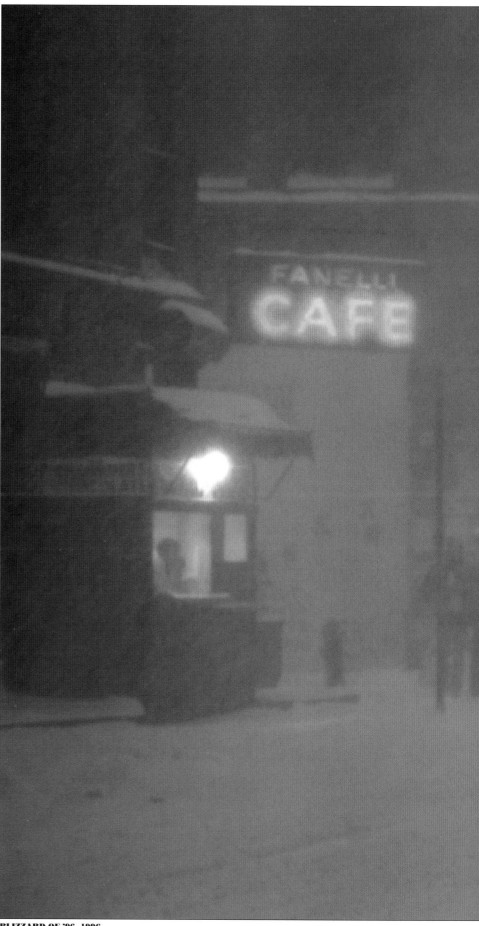

BLIZZARD OF '96, 1996

J. BARRY O'ROURKE

It was almost sunset, and the forest along the edges of Connecticut's Housatonic River was getting dark. O'Rourke had been waiting for more than an hour until—when the light was at its most dramatic—a boat roared by. "The only light that was getting through was on the waterskier and the plume of water," he says, amazed that an automatic meter could handle the tricky exposure and that an autofocus could handle the fast-closing object. A generalist who has done advertising, documentaries, commercials and more than 200 magazine covers, he says that boats are not his usual subjects: "I do mostly people things." But he likes the drama, the feeling of a captured microsecond in this frame.

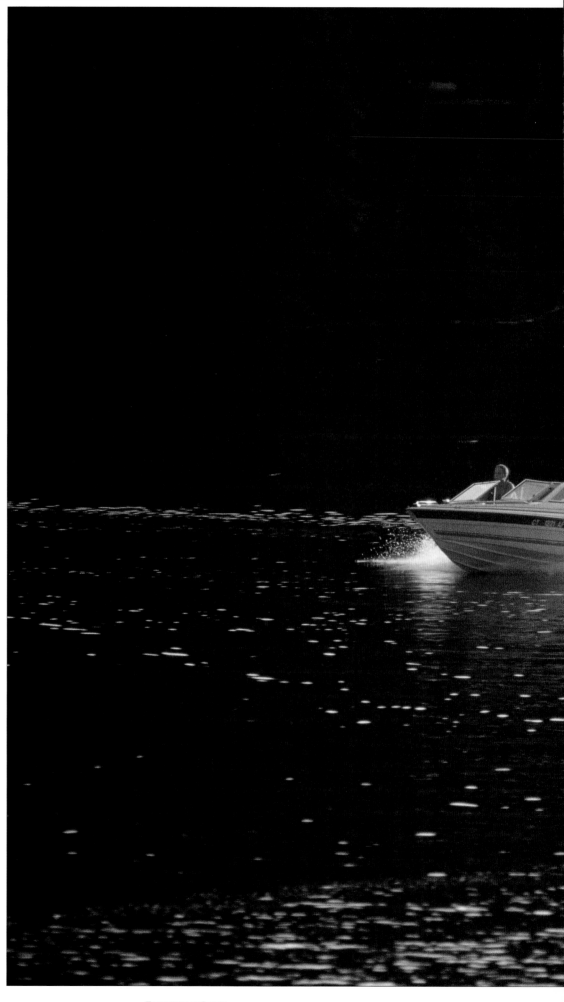

WATERSKIER, 1995

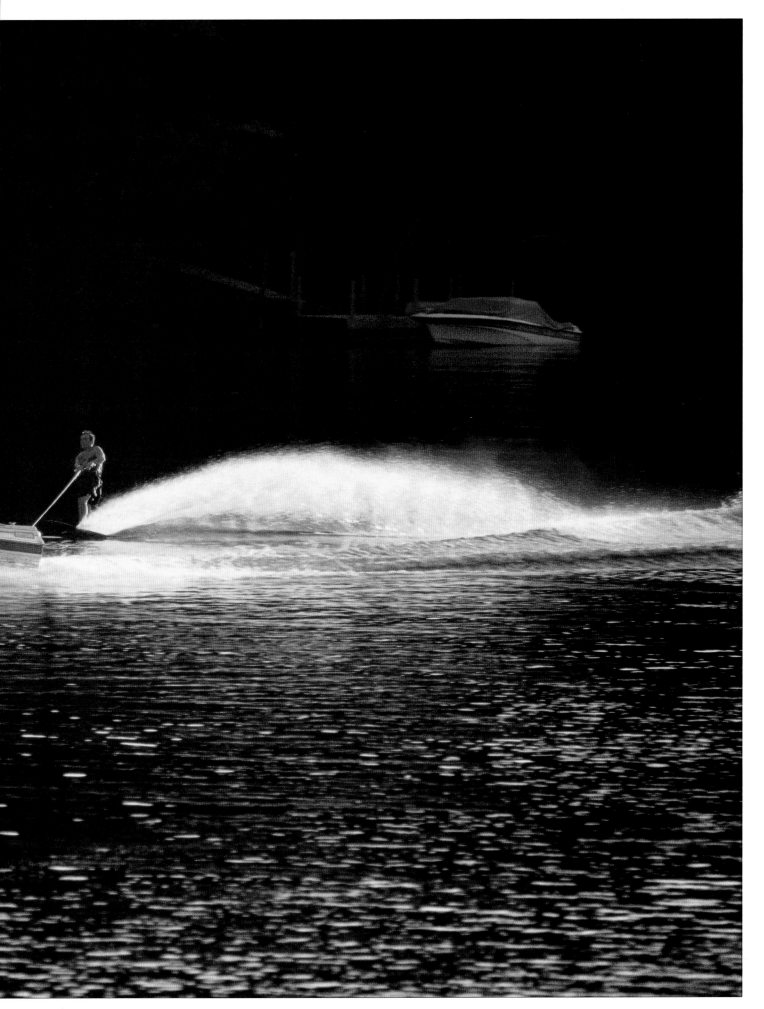

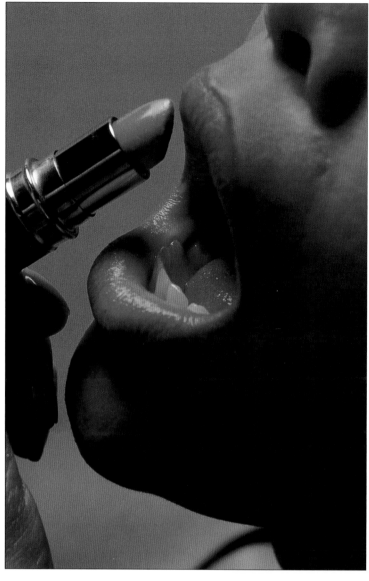

HENRY WOLF

"The camera is just a tool to produce imagery," says Wolf. "Its limitation is its inability to start from zero. The subject has to be there to be recorded, whether a glass of water or Mount Fuji—you can walk to it and put your hand on it." Still, there's recording and recording, as the legendary art director for such magazines as *Esquire* and *Harper's Bazaar* knows well. The ad above is straightforward. The model's face shot through a 5,000-watt bulb, by contrast, is conceptual. The unexpected combination, says Wolf, although in front of him physically, occurred in his mind's eye. "For a photograph to be memorable and unique, the photographer himself—his prejudices, fantasies, background, love life—have to be part of the picture."

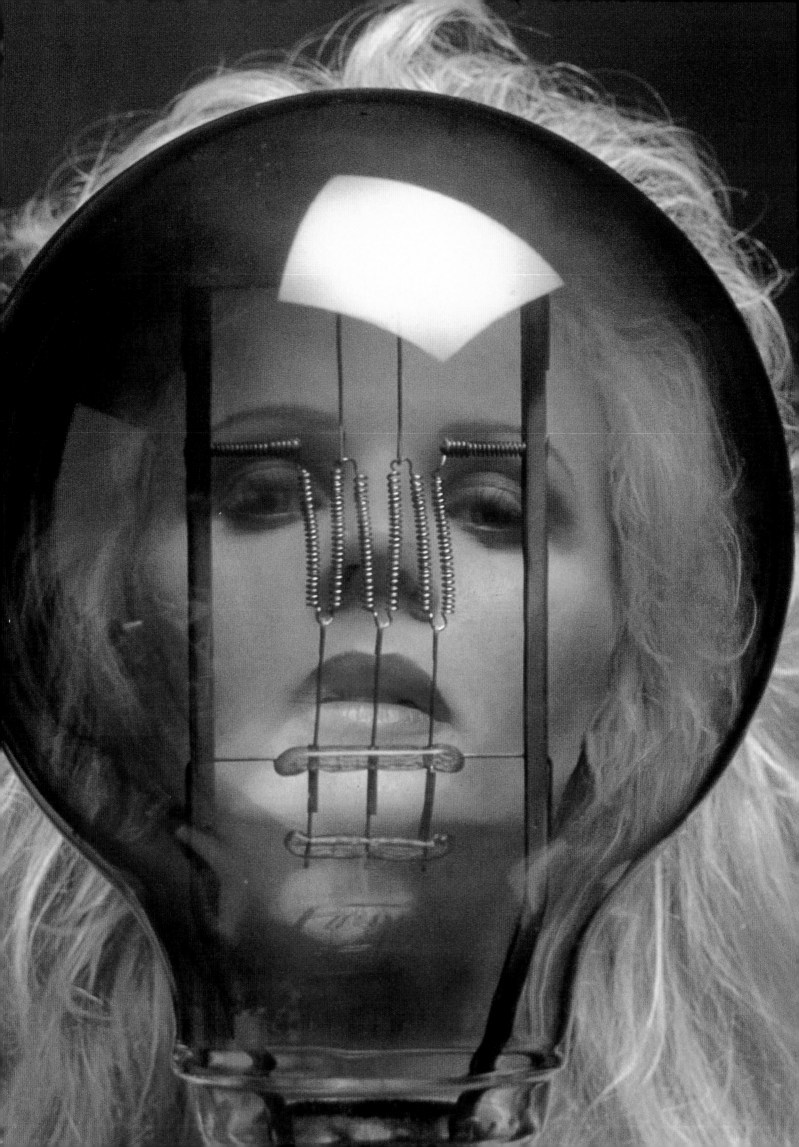

GIL SMITH

During the planning stages of an ad campaign for Oakley, Inc. sunglasses, Smith, who usually specializes in automobile advertising, took a hard look at sports photography. "I wanted to create a whole new look. Right there. In your face," he decided. He tried it out in this shot of Bryan Iguchi, a world-class surfer turned world-class snowboarder. Smith attached a special camera rig with a remote trigger to Iguchi, catching the athlete making radical moves in Aspen, Colorado. "I like the liquid feel, like surfing in snow," says Smith. "There's a fluidity to it. It just feels weightless." After a single lesson on a board, Smith, a proficient skier, knows firsthand the skill it takes to achieve Iguchi's form. He decided to be content with translating it to film. "I like to make page-stoppers," he says. "I try to create a hyper-reality."

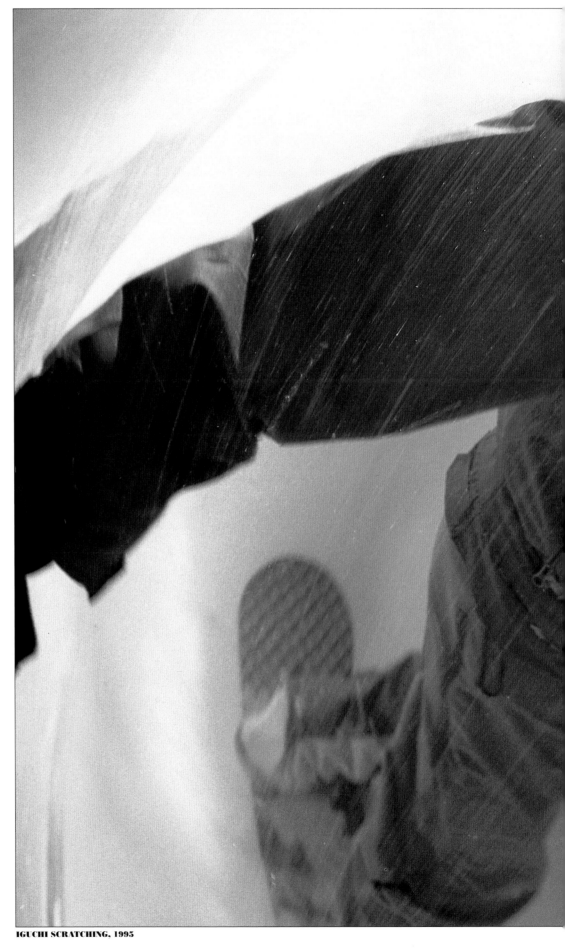

IGUCHI SCRATCHING, 1995

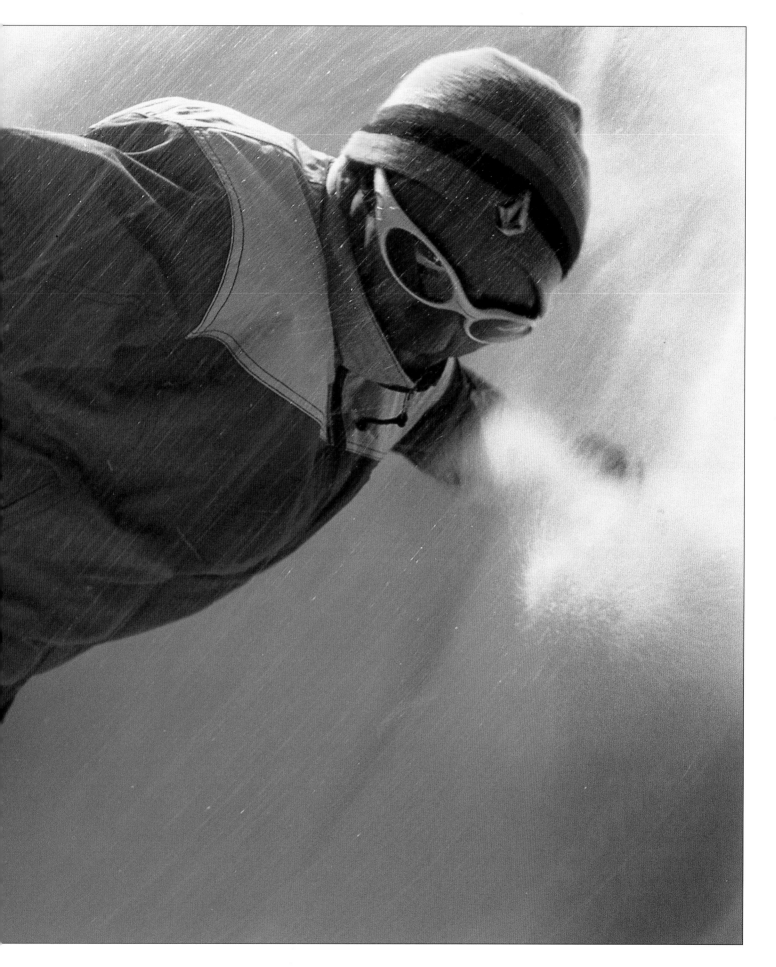

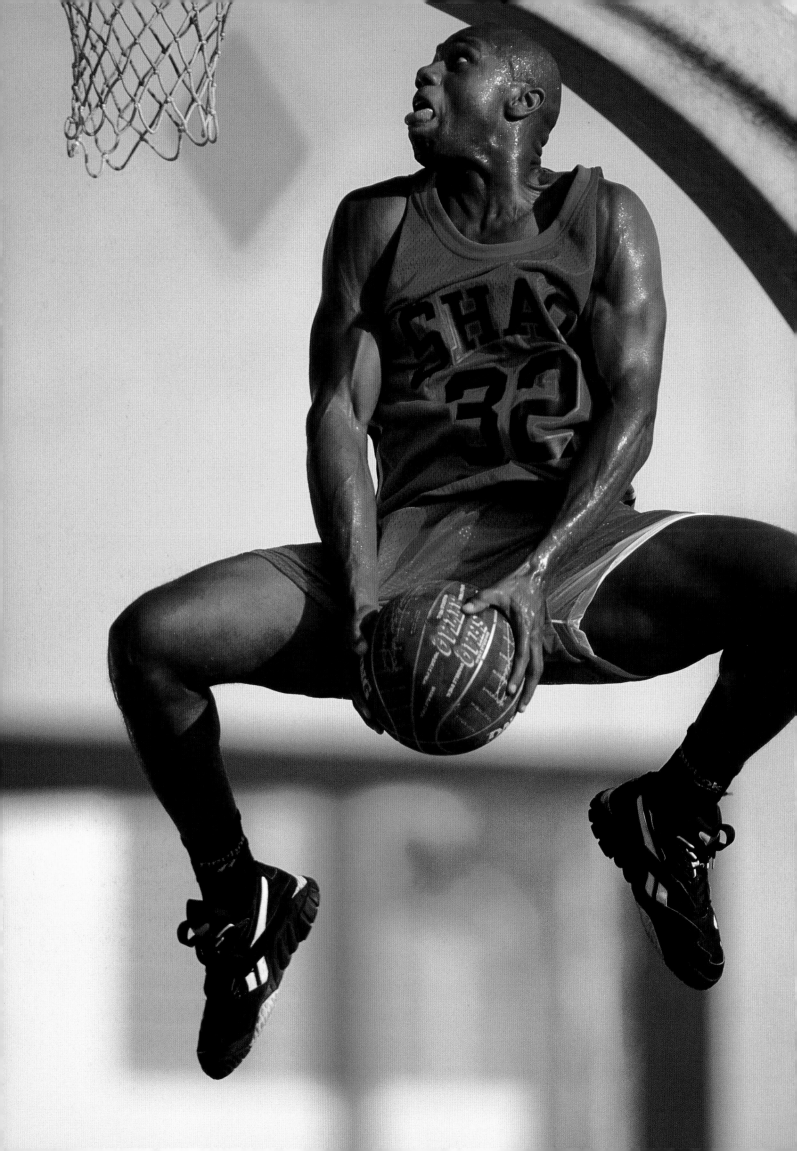

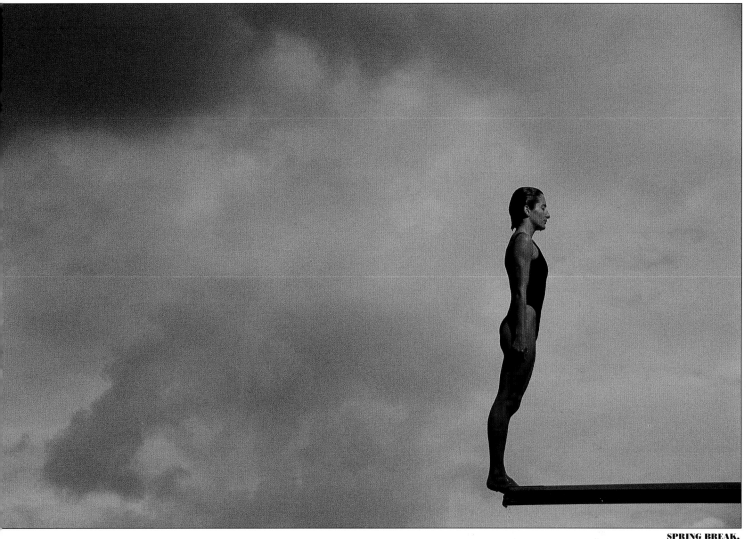

WALTER IOOSS, JR.

"I just let things take place," says the sports photographer. He's not averse to helping the process along, though. He took time out to make this picture of a diver during an ad shoot, putting his assistant with a strobe light on a higher diving board. For the basketball picture, he searched Miami for a site with beautiful light and low baskets—"the model was not that big a guy, only about six feet two." He found the perfect spot in an elementary school.

"Given the right person, the right place, the right light— I try to take the best action shot I can," he says. In addition to longtime work with *Sports Illustrated*, Iooss has done many books, including the best-selling *Rare Air* with Michael Jordan. He himself has played baseball, basketball and tennis, but his latest high is surfing. Still better is taking pictures: "I love to work one-on-one with great athletes. That's my greatest joy."

MIAMI SLAM, 1994

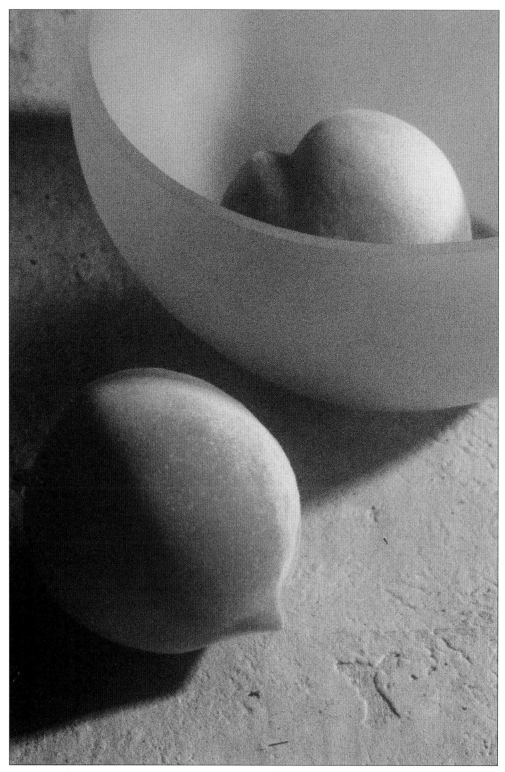

PEACHES, 1995

CAROL KAPLAN

"Most commercial photography has a hard edge to it," says the Boston-based Kaplan. "I try to give everything a slightly romantic look." She usually photographs people rather than still lifes, working with all age groups from infants to adults. But clients most often come to her for her work with children. Her favorite age is three to five years old, when a child has a longer attention span than a toddler but is still not self-conscious. "I don't say, 'Smile' or 'Look worried.' I just play with them, talk to them and try to get reactions," says Kaplan, herself the mother of two. "I like the children—and the pictures—to be spontaneous." Whether shooting peaches or a peach of a girl, her frames share a sensibility: "I like soft lights, soft colors. I want all of my pictures to have a natural look."

WYATT, 1995

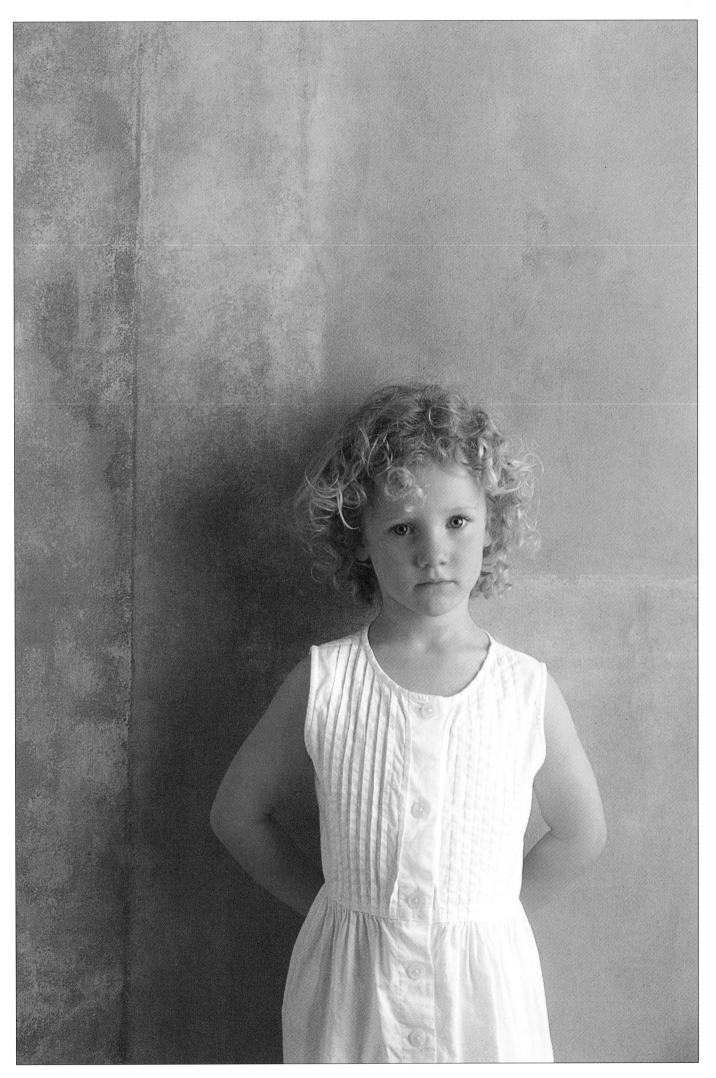

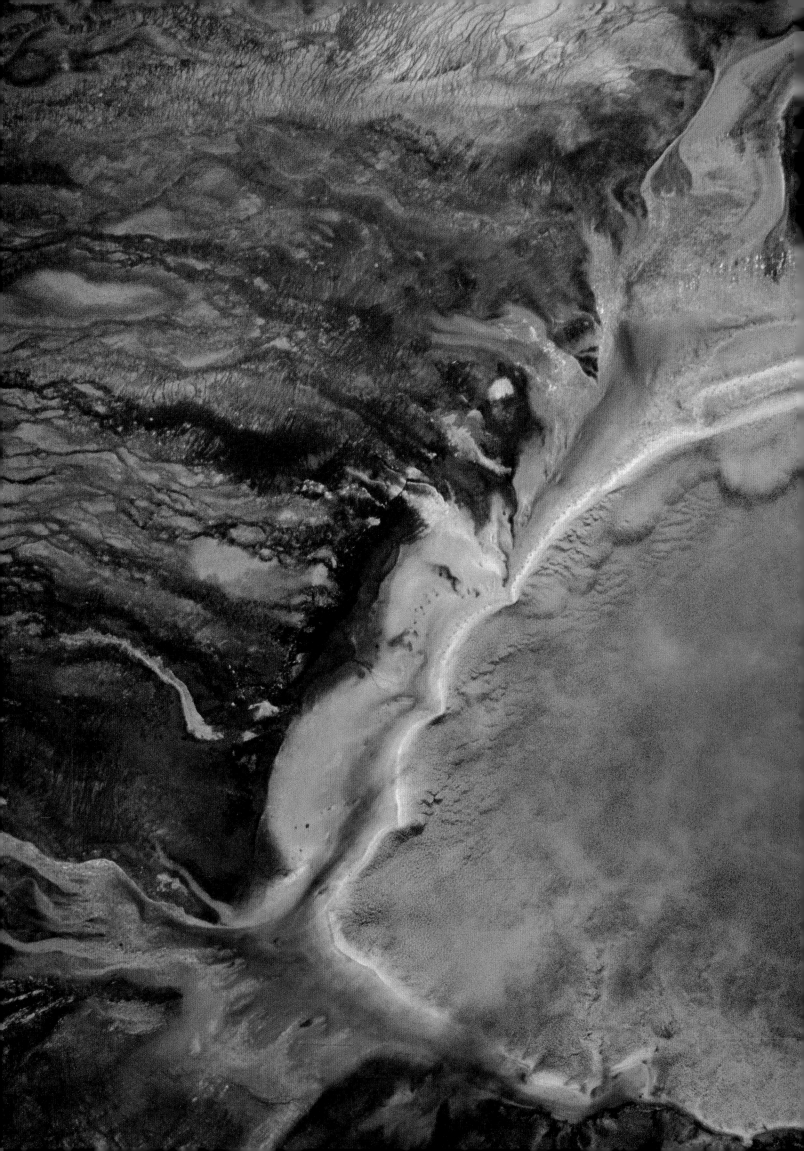

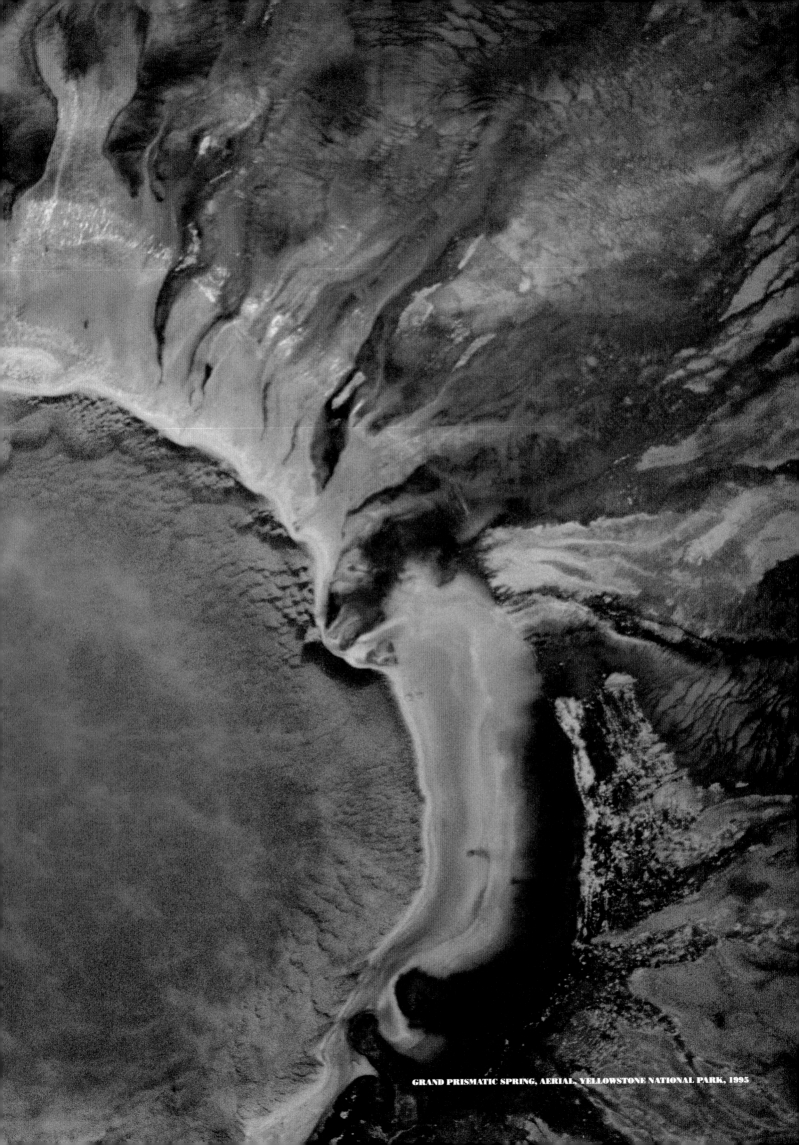

GRAND PRISMATIC SPRING, AERIAL, YELLOWSTONE NATIONAL PARK, 1995

◄ **PRECEDING PAGES**

WILLIAM NEILL

The challenge for a nature photographer is to delight and surprise as well as to educate. Hovering over this football-field-size spring of photosensitive algae for a new book called *The Color of Nature*, Neill framed out everything that might give the viewer a sense of scale. "I wanted it to be less descriptive, more enigmatic," he says. "I'd rather take a picture that asks a question than one that answers a question." Landscapes photographed as often as Yellowstone become so familiar that finding a fresh view can be difficult. But Neill has experience in that area— he has lived and worked in Yosemite National Park for two decades. "Transcending the cliché," he says, "can be a full-time job."

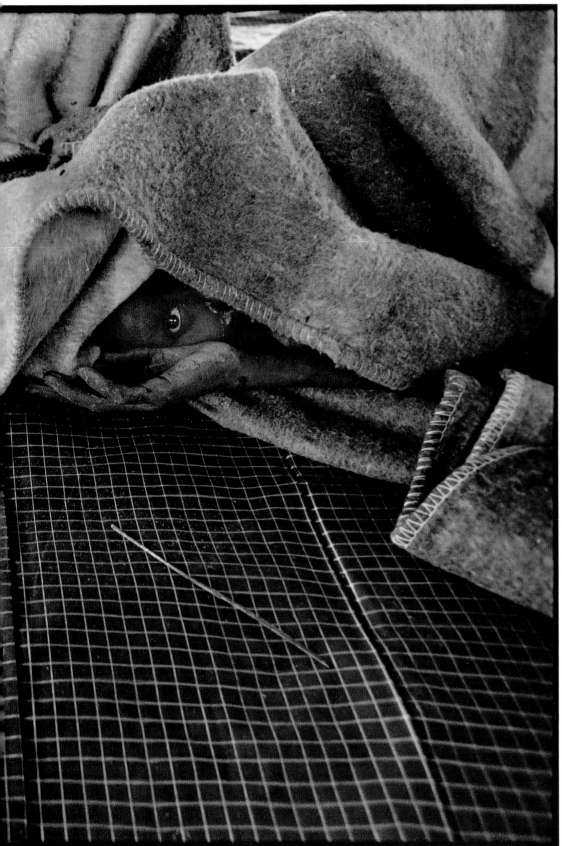

SOUTHERN SUDAN, 1992

JAMES NACHTWEY

In a town called Ayod, a starving boy eyes a bowl of rehydration fluid in a feeding center. Sadly, the decade-long famine in the Sudan is largely man-made, product of a civil war between the Islamic government based in the north and the animist African peoples of the south. An eminent war photographer, Nachtwey has seen the terrible destruction humans wreak on each other over and over—in El Salvador, Lebanon, Sri Lanka, Haiti, Bosnia. But he has also seen the good people can do: An outpouring of humanitarian aid often follows publication of images like this one. "There's no other reason to take these pictures. They appeal to what's best in people, to their generosity and humanity," says Nachtwey. "It's important to understand issues, not as social or political abstractions, but for the effect they have on people. I try to make a human connection."

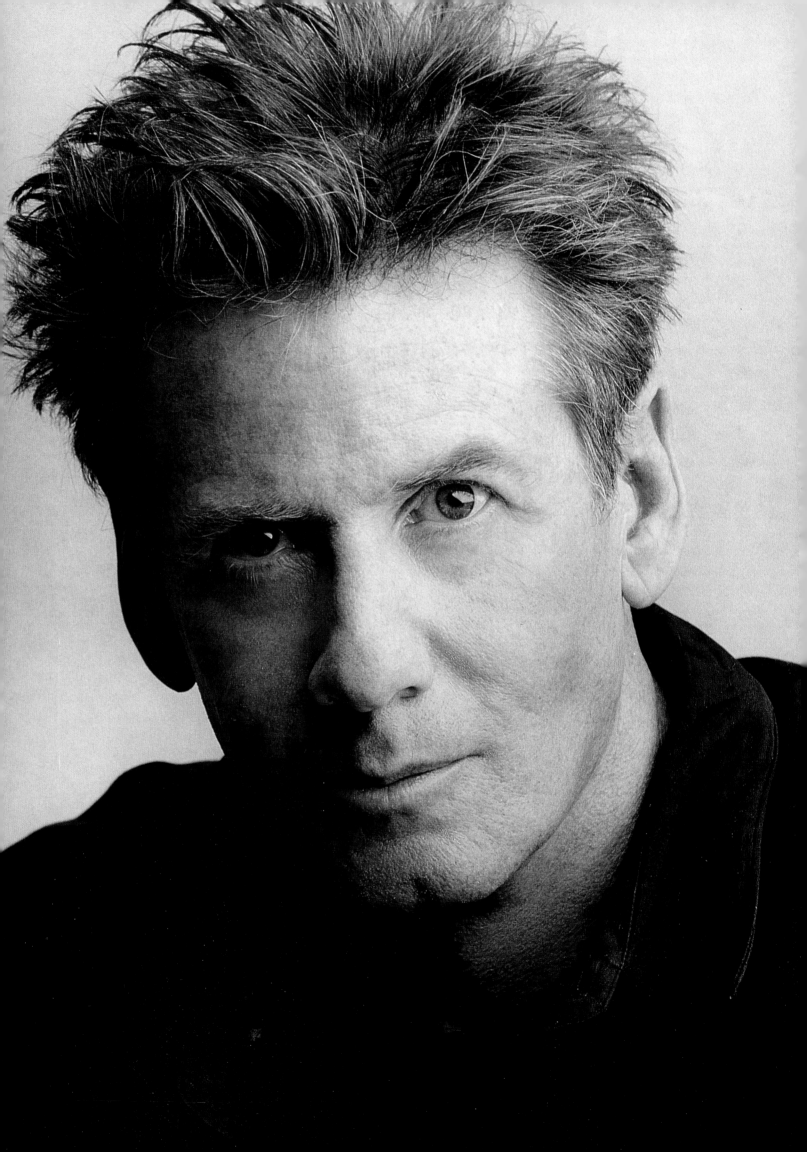

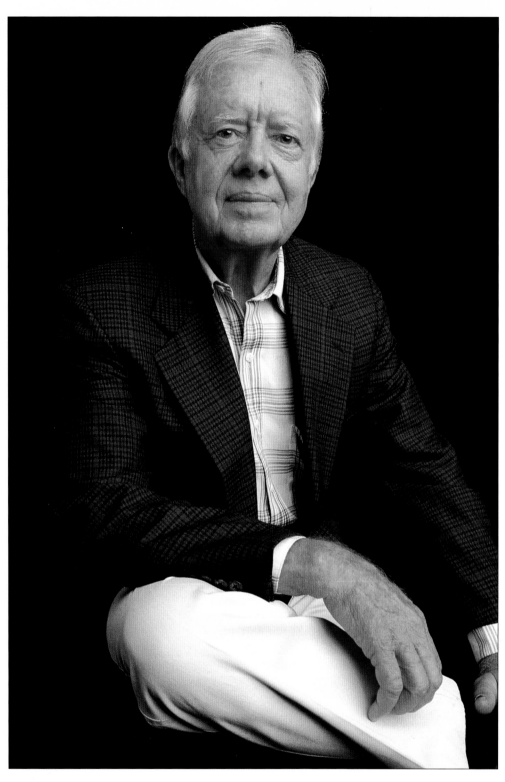

JIMMY CARTER, 1995

TIMOTHY GREENFIELD-SANDERS

His subjects look straight into the lens. The style is simple and straightforward—lighting, backdrops and poses. He came from the world of fine art, making portraits of painters and sculptors with large-format cameras. As he moved into mass market work, his subjects became increasingly well known. "Celebrities like Calvin are very comfortable in front of the camera. They know how to show you their best sides," he says. He usually works in his home studio, an old church rectory in New York City. The quick response time of a 35mm camera is most important when he has to travel—or has just fifteen minutes in Plains, Georgia, with a former president. But he also finds a small camera liberating: "It loosens me up."

CALVIN KLEIN, 1995

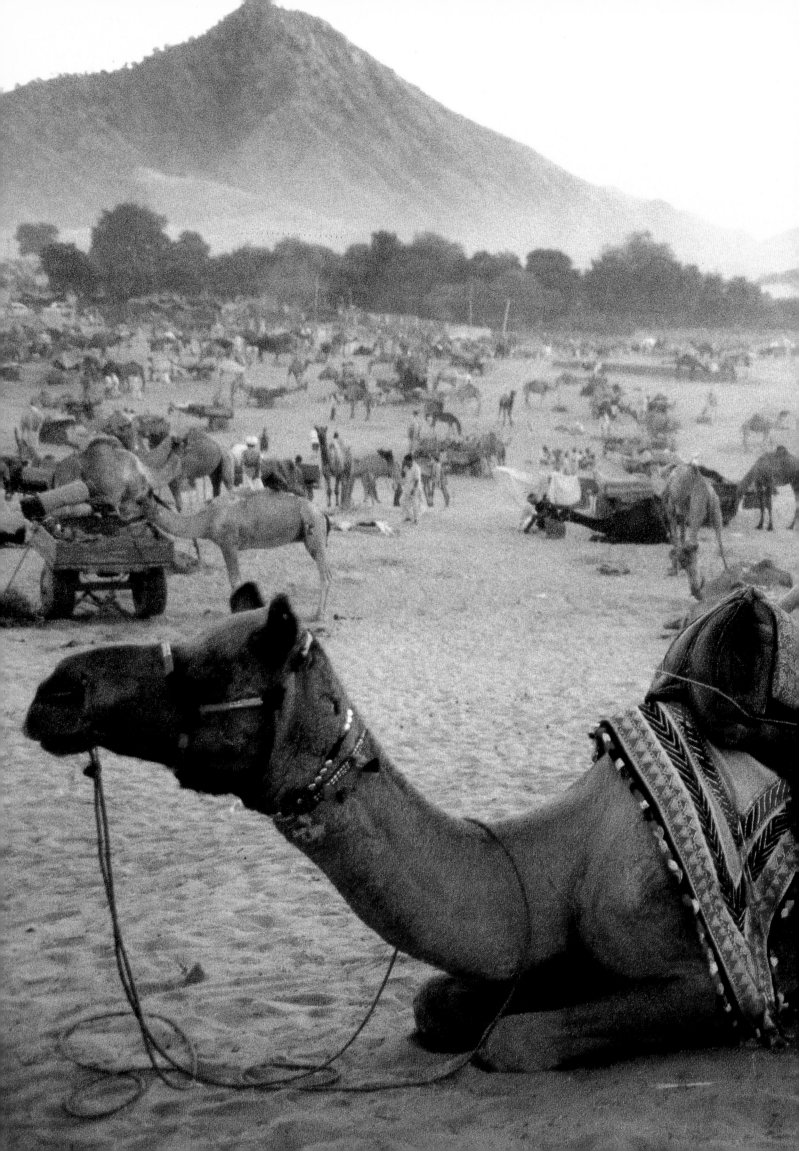

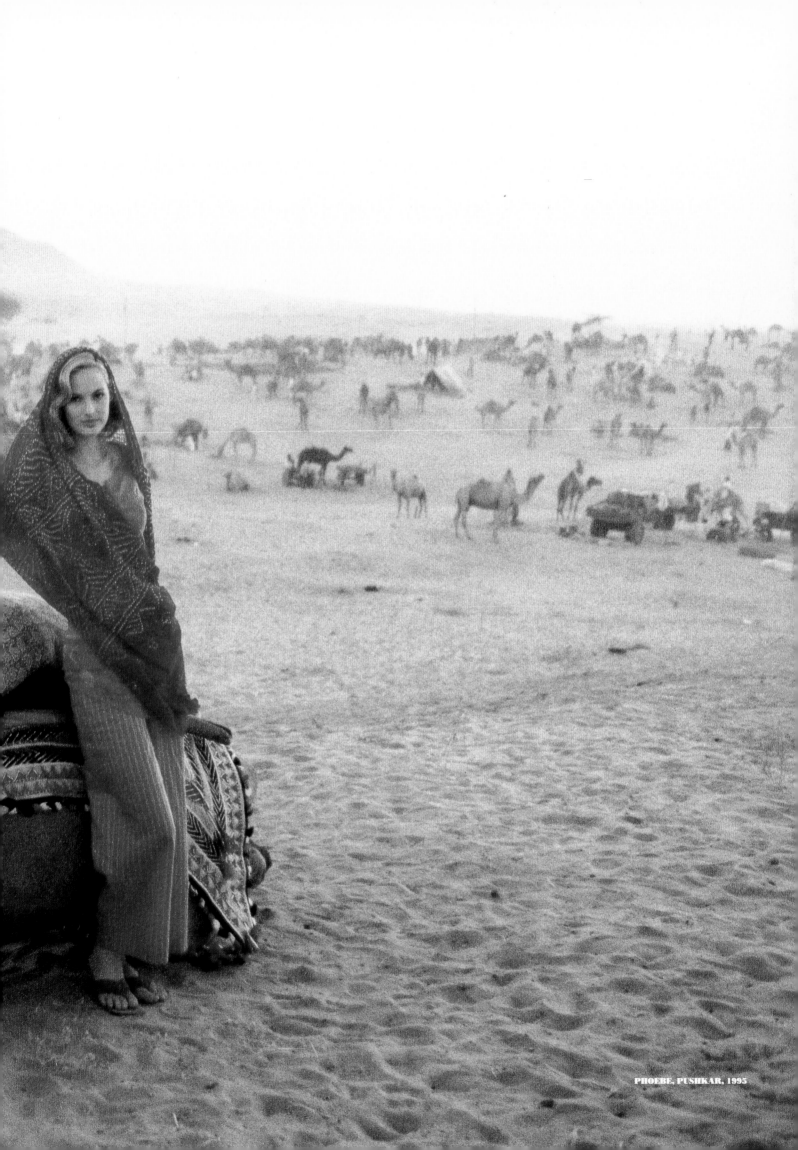

PHOEBE, PUSHKAR, 1995

JOEL MEYEROWITZ

"The play of light on things has always been moving to me," says Meyerowitz. "It's not just an optical experience—it has to move my spirit. It's a feeling of something transcendent that touches you, viscerally. You come awake." The man whose books like *Cape Light* and *Bay/Sky* have defined the seacoast was closing up his own house on Cape Cod for the winter when he made this picture. "I was called out by the sudden light in the sky," he recalls. "It painted itself this iridescent color, not over the water but over these simple dwellings huddled together. The season was over, and it was as if the sky were saying good-bye—as simple a little poem as that." Just such "simple" Meyerowitz images adorn the nation's most prominent art museums.

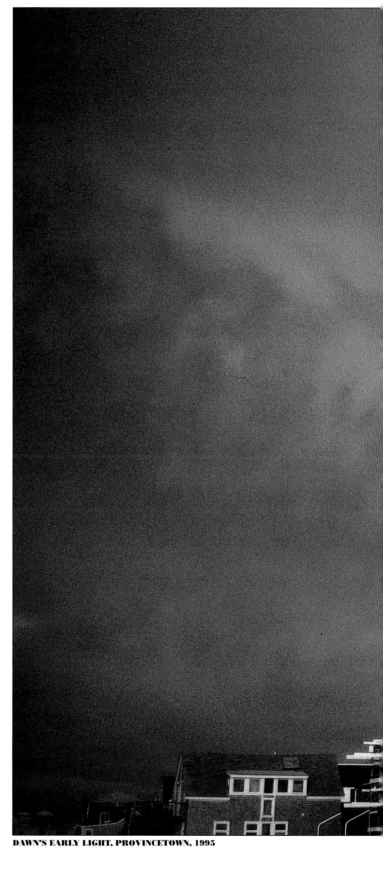

DAWN'S EARLY LIGHT, PROVINCETOWN, 1995

◄ PRECEDING PAGES

SHEILA METZNER

The moon was full, and families from all over India gathered near a lake for a purification ceremony. Their encampment, with some 10,000 horses and 50,000 camels, was part festival, part bazaar. "We were in a sacred place, doing a profane thing—a fashion shoot," says Metzner. "But at sunset everything quieted, and we were all reduced by the grandeur of the space." Capturing sacred spaces, whether in exotic high fashion or more domestic images of her children, is Metzner's forte, one that has made her photographs widely known. "My work is about the relationship between people and their place on earth. I'm for a historical, mythical, story-telling quality. My pictures—even the fashion ones—are about search and transformation."

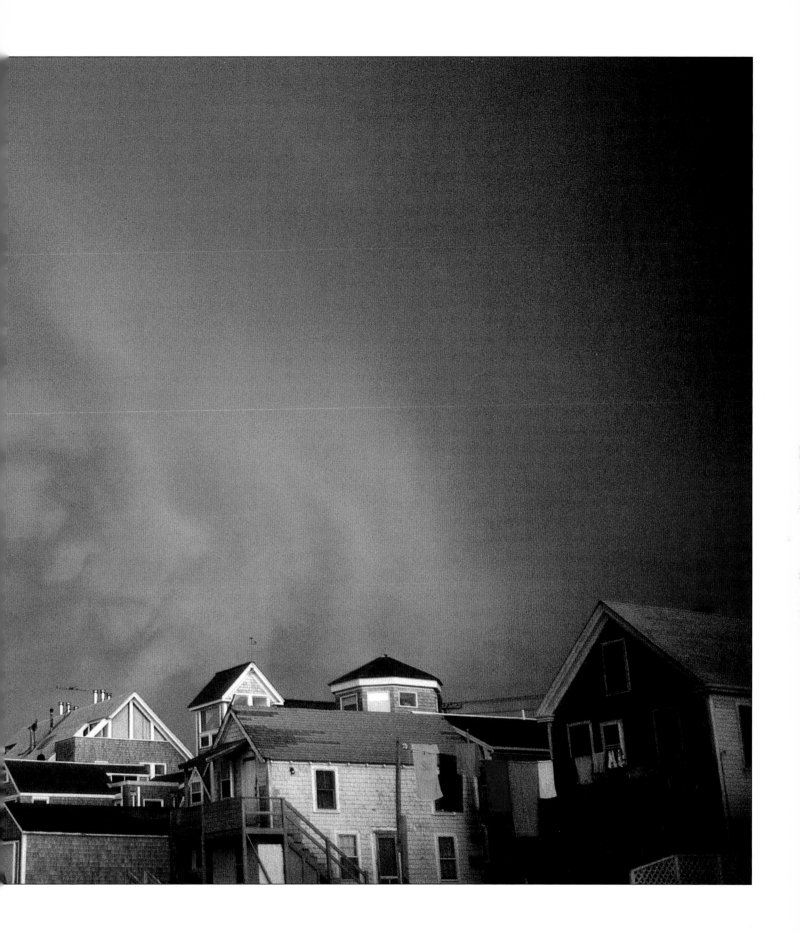

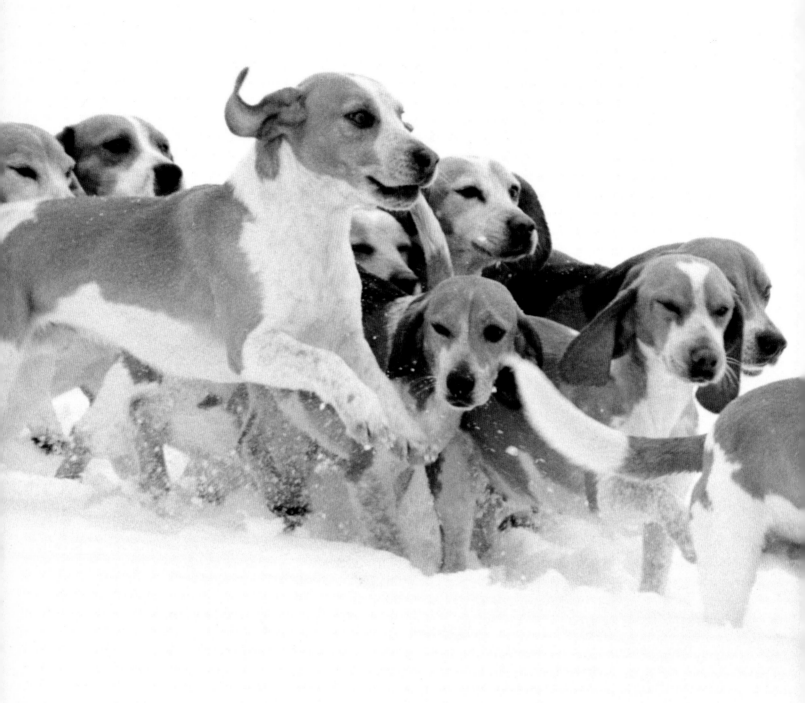

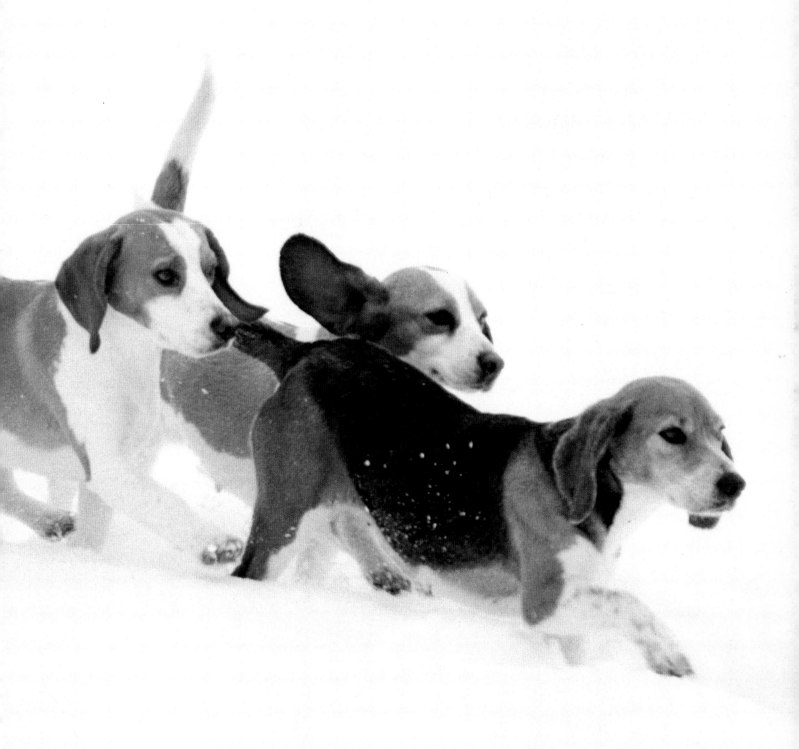

BEAGLES, 1995

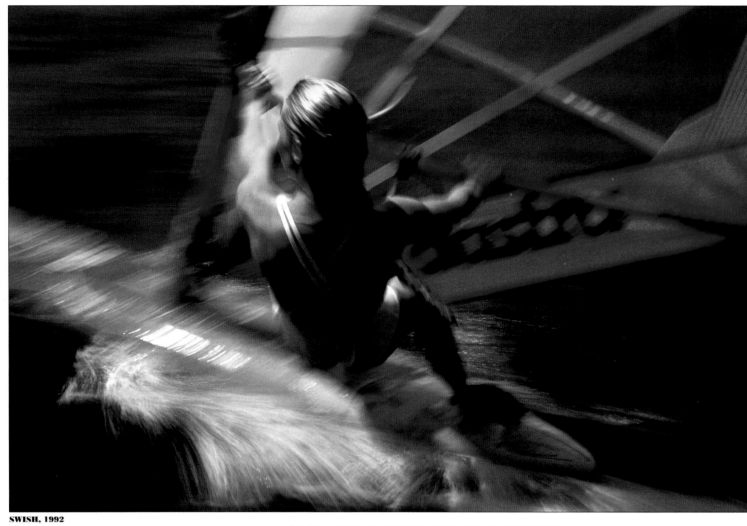

SWISH, 1992

CO RENTMEESTER

In heavy waves off the coast of Maui, Rentmeester focused from a 21-foot boat as this windsurfer sped by at 30 mph. "My assistant was green in the face," he says. After covering the Watts riots in Los Angeles and being shot by a Vietcong

◄ PRECEDING PAGES

ANTHONY EDGEWORTH

It was ten degrees below zero in Unionville, Pennsylvania, when Edgeworth saw stockbroker-turned-sculptor Clayton Bright set off with his pack of beagles. The photographer was putting together his book *Brandywine,* taking pictures of the many characters—including the Wyeth and Du Pont families—that give the area its interest. "There are a lot of artistic genes there," he notes. His are just as classical. "I like a certain order, clean lines and balance," he says. "I frame as if in a picture frame." The light on the pack was just what he wanted, a flat light that gave the picture "a stark emptiness." His equipment overcame "the natural hazard of subzero temperatures" to produce a classic photograph of a class act.

SPEED, 1993

sniper while on assignment for *Life* magazine in the '60s, Rentmeester didn't find this Pacific adventure particularly perilous. Himself an oarsman who rowed on the Dutch Olympic team years ago, he has always liked photographing sports. "The emphasis is on power and speed," he says of his pictures of Mike Tyson, Mark Spitz, Carl Lewis and others. "It's not subtle or soft, but bold and dramatic. And with a female athlete, you also get grace."

LARRY DALE GORDON

"I've always loved graphics and color, in both man-made objects and nature," says Gordon. He has lived all over the world and shot in exotic locales like the Himalayas *(below)*, but settled in one of the most beautiful places he knows, Big Sur, California. There, while working for advertising and editorial clients, he is also making a transition to fine art photography like the nude series "Textures." He finds it a challenge to make all of his own artistic decisions. "I became a photographer because I wanted to be an independent soul," he says. "Now, at last, I'm able to do images without anyone leaning over my shoulder. You look to yourself to say, 'Have I finished this picture?'"

BHUTANESE FESTIVAL DANCER, 1994 TEXTURES SERIES, THE FEATHER, 1995

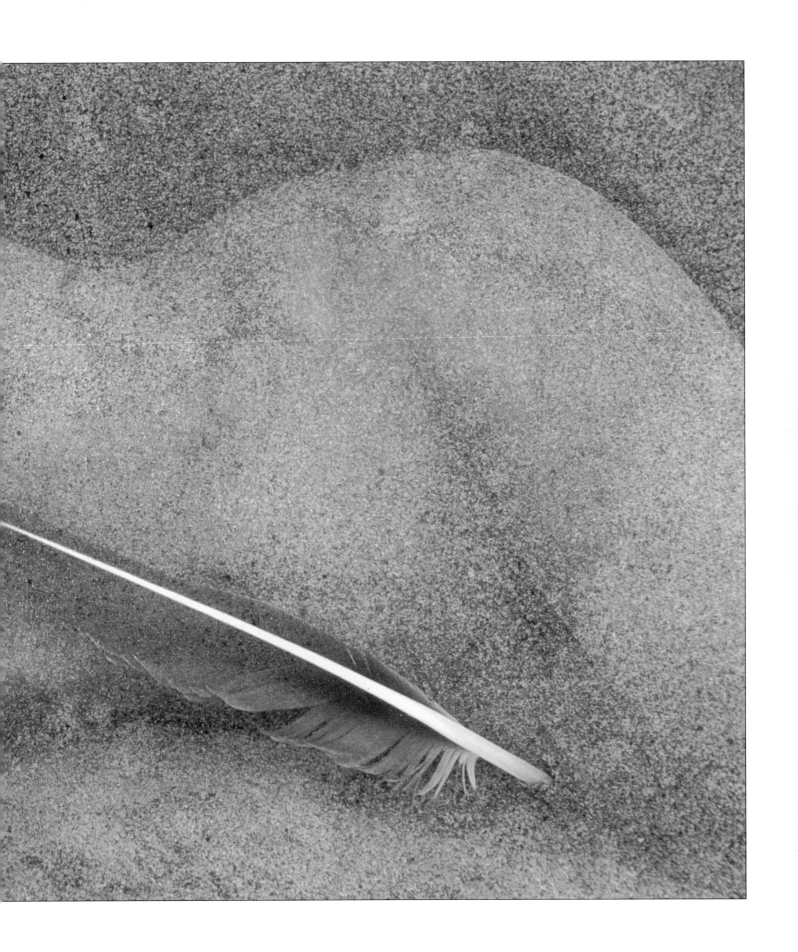

PAUL ARESU

"I don't like things that look real," says Aresu. "I like more abstract images." He learned some of the techniques he uses to push reality as a boy in his father's photography studio and darkroom. After college training and apprenticeships for top photographers, he set up his own studio, specializing in still lifes for advertising. This bicycle series reflects his own passion for mountain biking. "I shoot things that are close to me." He uses special lighting and processing to get his effects. "With a white light, it feels like an unfinished painting to me," he says. "I like very vivid, strong, manipulated colors. When I put on color gels—that's when it all comes together as a finished image for me."

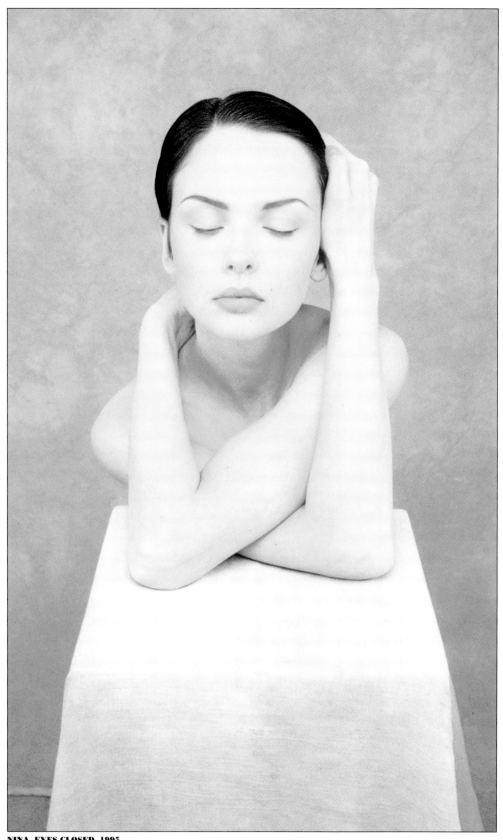

NINA, EYES CLOSED, 1995

JOYCE TENNESON

"I have always been intrigued by the dual nature of people, the inner and the outer," says Tenneson. Her mother had a twin sister, and Tenneson was fascinated by the difference in their personalities—her mother an interior person, her aunt an outgoing one. She came to believe that everyone has a shadow self, and photographs like those in her recent book

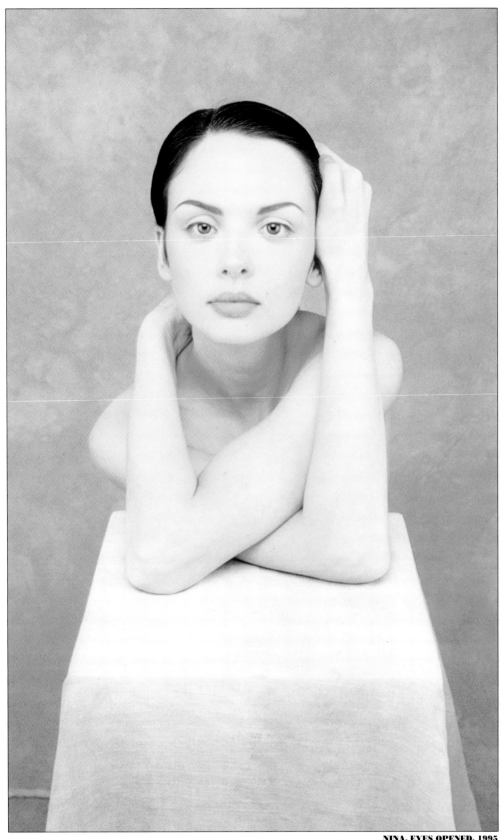

NINA, EYES OPENED, 1995

Transformations capture this psychological dimension. Nina, a musician friend from Russia, could move her body in mysterious ways. To add yet more mystery to her inward-outward metaphor, Tenneson used a monochromatic scheme. The focus is on the meaning of the image rather than on its look: "I'm always interested in penetrating below the surface."

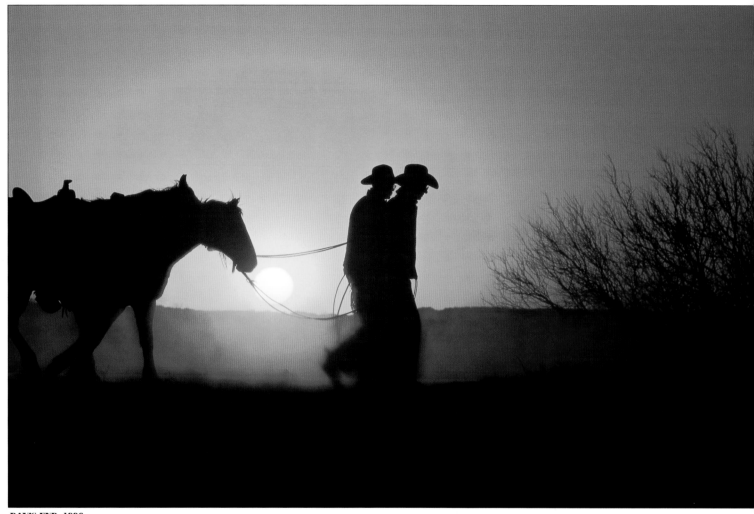

DAY'S END, 1996

DAVID R. STOECKLEIN

"I'm a real student of the history of the West," says Stoecklein, a Pittsburgh native who headed toward the setting sun as soon as he was old enough. He eventually put down roots on a ranch in Idaho, complete with livestock. The passion he feels for authentic western life comes across in his images—of cowboys headed back to camp after a day's work or a calf being carried back to the barn in a blizzard. Such images are in demand for brands like Jeep, Copenhagen snuff, Chevy and, of course, Marlboro. Stoecklein made the sunset picture *(above)* on one of the largest working ranches in Texas, near the Tongue River. "At the Moorhouse Ranch they handle cattle with horses, the way it's been done for hundreds of years," he says. Stoecklein appreciates tradition, but he's not hidebound. "I'm an advertising photographer," he says. "If I want snow tomorrow in Arizona, like a movie director, I make snow."

WINTER RESCUE, 1996

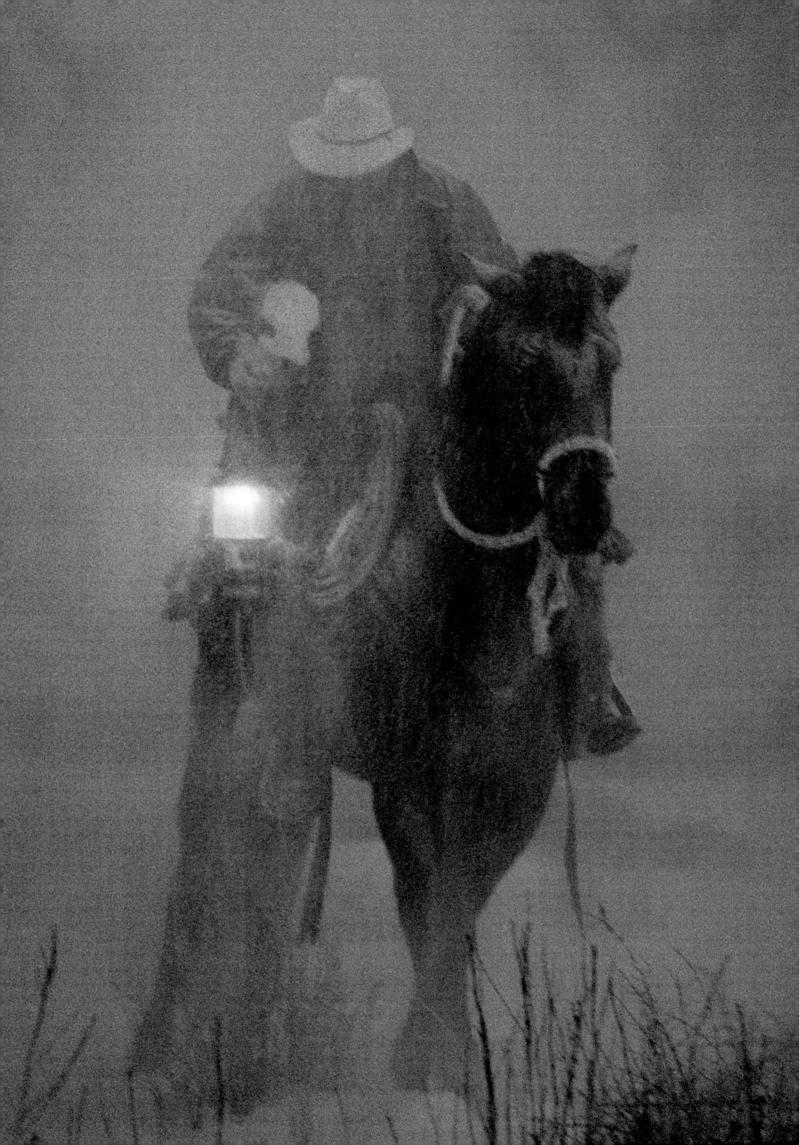

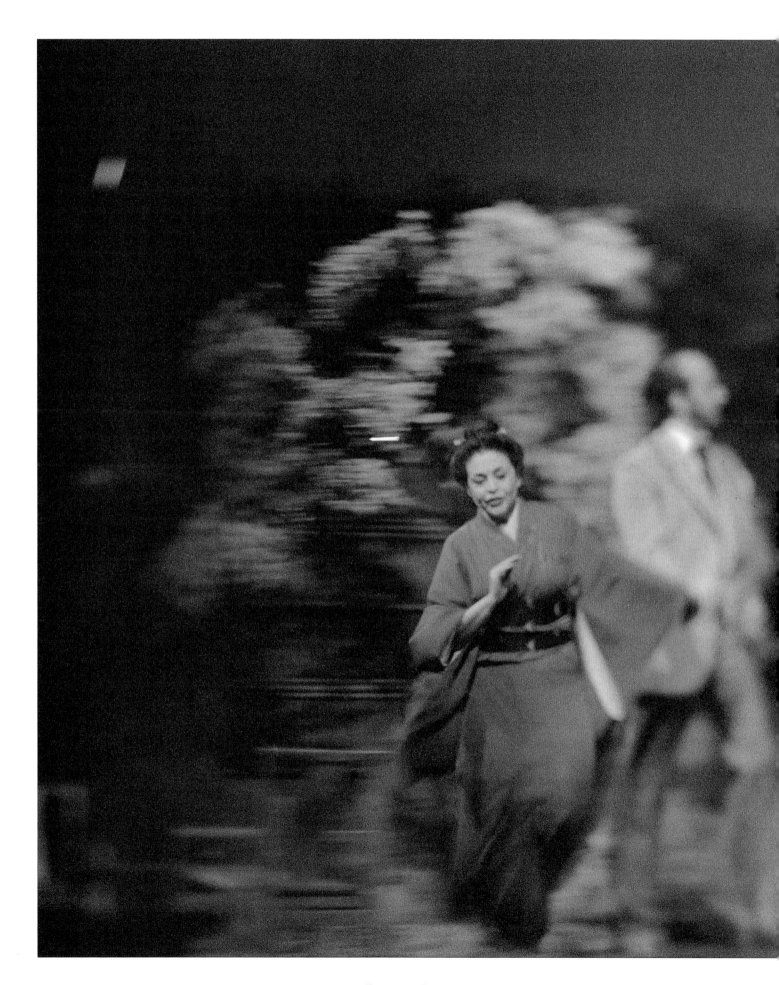

GREGORY HEISLER

Shooting at a dress rehearsal of the Metropolitan Opera was a challenge. A well-known portraitist who has done many *Time* magazine covers, including three for Man of the Year, Heisler ordinarily controls the lighting of his subjects very carefully. "My portraits almost always involve unique, stylish and idiosyncratic lighting," he says. "But this picture, shot under very uncontrolled circumstances, has an emotional and unreal quality." He used a special lens allowing him to work in low light, blurring the background to isolate the figure. "I search for the right photo tools to get the best response to the story content. For somebody as slick and shameless as I am," he laughs, "my pictures are driven by content—not gimmicky."

MADAMA BUTTERFLY, 1994

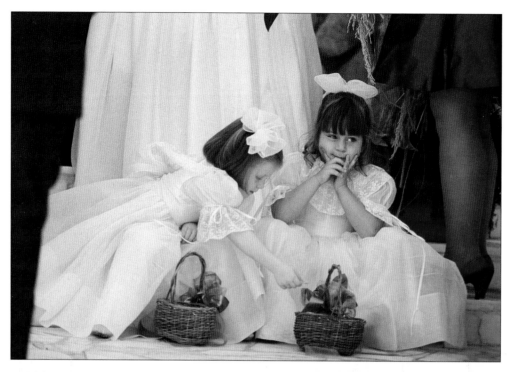

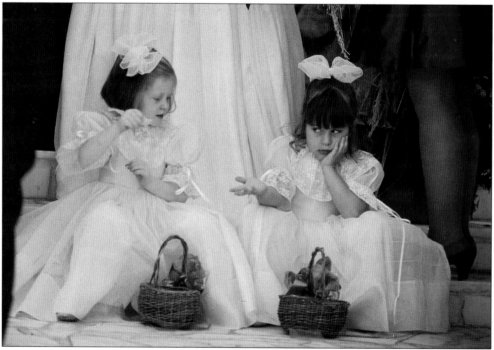

FLOWERS,
FLOWERS, 1996

DENIS REGGIE

Sidelined with a football injury, Reggie began to take pictures of games rather than play them. He learned to watch faces and anticipate the action. When he attended the wedding of an old girlfriend, he was struck by the insensitivity of the photographer. "While he was arranging her dress for a posed picture, he missed the most fascinating moments. I began to think about how weddings—melodramatic, hokey, Elvis-on-black-velvet treatments—could benefit from a documentary approach." He has been so successful in quietly observing rather than directing, that he has documented 16 Kennedy family weddings (including Maria Shriver's and Caroline Kennedy's), along with those of Mariah Carey, Holly Hunter, James Taylor and other stars. The bored flower girls *(above)* or a couple headed into their future are moments to treasure. Is he married? "I'm weddinged out," he says. "All my emotions come through the lens."

GARDEN WALK, 1996

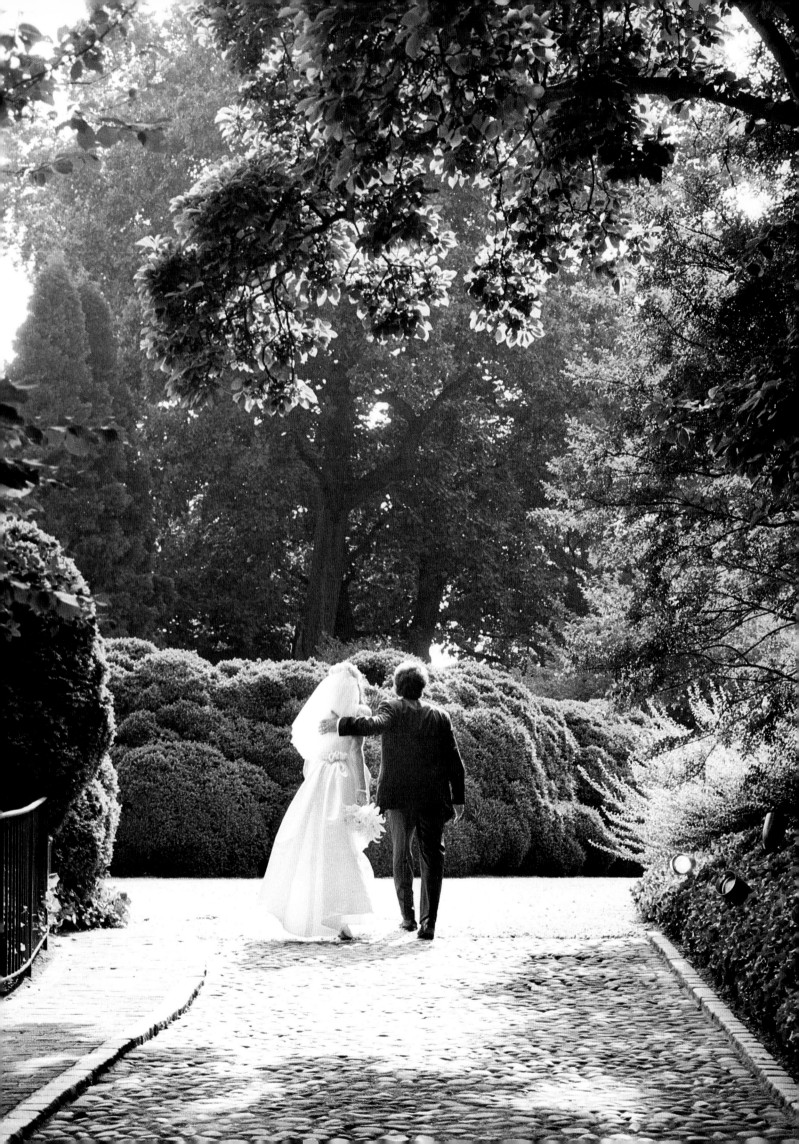

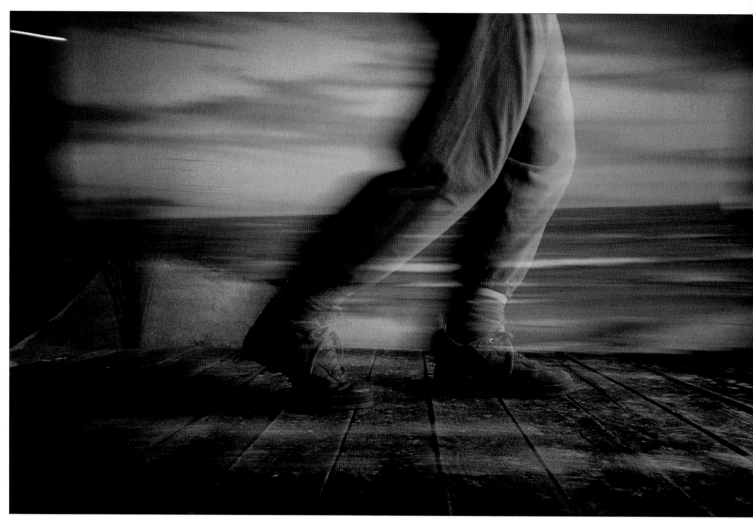

NICK VEDROS

"The only thing that limits you is your imagination," says Vedros. Despite his degree in journalism, his work has strayed far from the documentary. The walking picture was made during an advertising shoot indoors in the wintertime, against a painted background in his turn-of-the-century firehouse studio in Kansas City, Missouri. The symbolic image of America's troubles was created in his mind, then meticulously assembled. He may spend an entire day, working with two or three assistants, on one or two such shots. "Not much is left to guesswork or chance," he says of his controlled techniques. But they make for what he calls "uncommon stock."

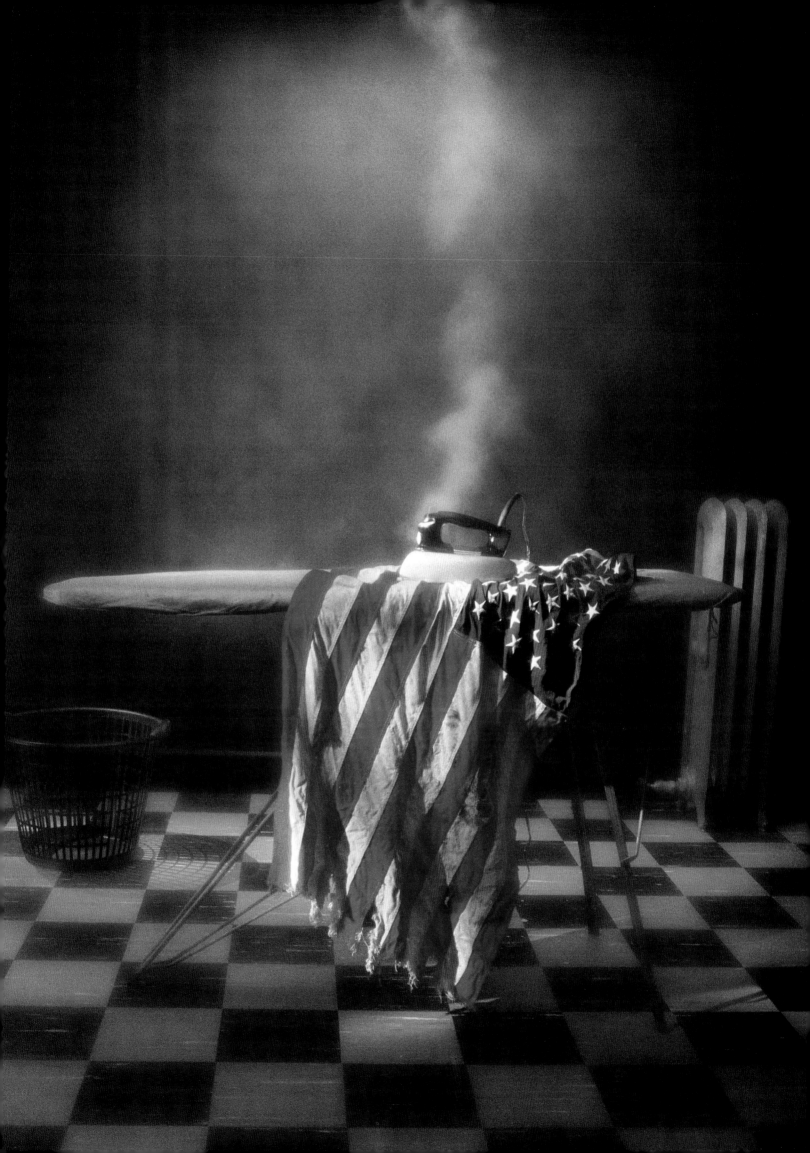

PATRICK DEMARCHELIER

He does record album covers for Madonna and Billy Joel, movie publicity for Warren Beatty, television commercials for Revlon and Calvin Klein, and family portraits for Princess Diana. He has taken pictures of famous faces from Twiggy to Nancy Reagan. But primarily, for the past two decades, the New York City–based Demarchelier has worked in fashion photography, for clients like Ralph Lauren, the Gap and Chanel, and for magazines like *Vogue, Glamour* and *Harper's Bazaar.* This shot was part of a twelve-page layout in American *Marie Claire* taken in Peru. The model, Helena Christiansen, was beautiful, and the location, an ancient Incan city in the Andes, was as well. When all circumstances converged, says Demarchelier, "It was magic. Very special."

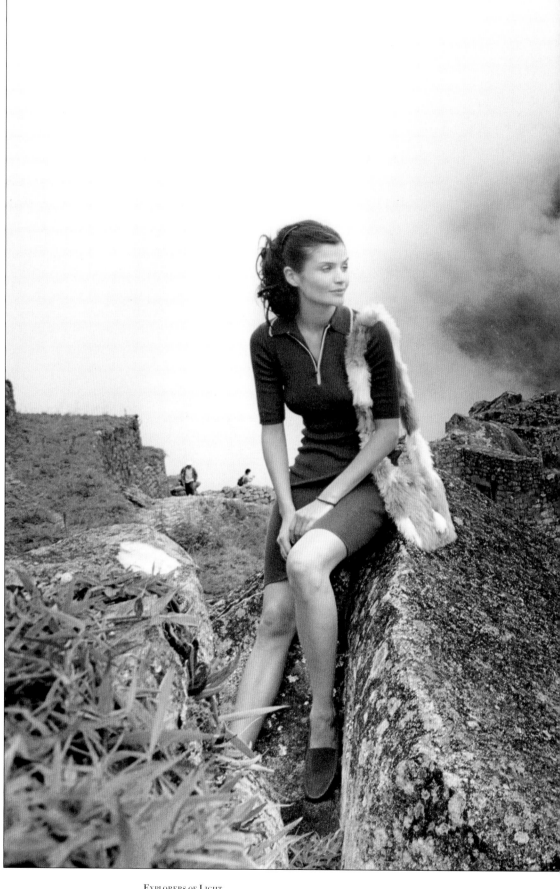

MACHU PICCHU, 1996

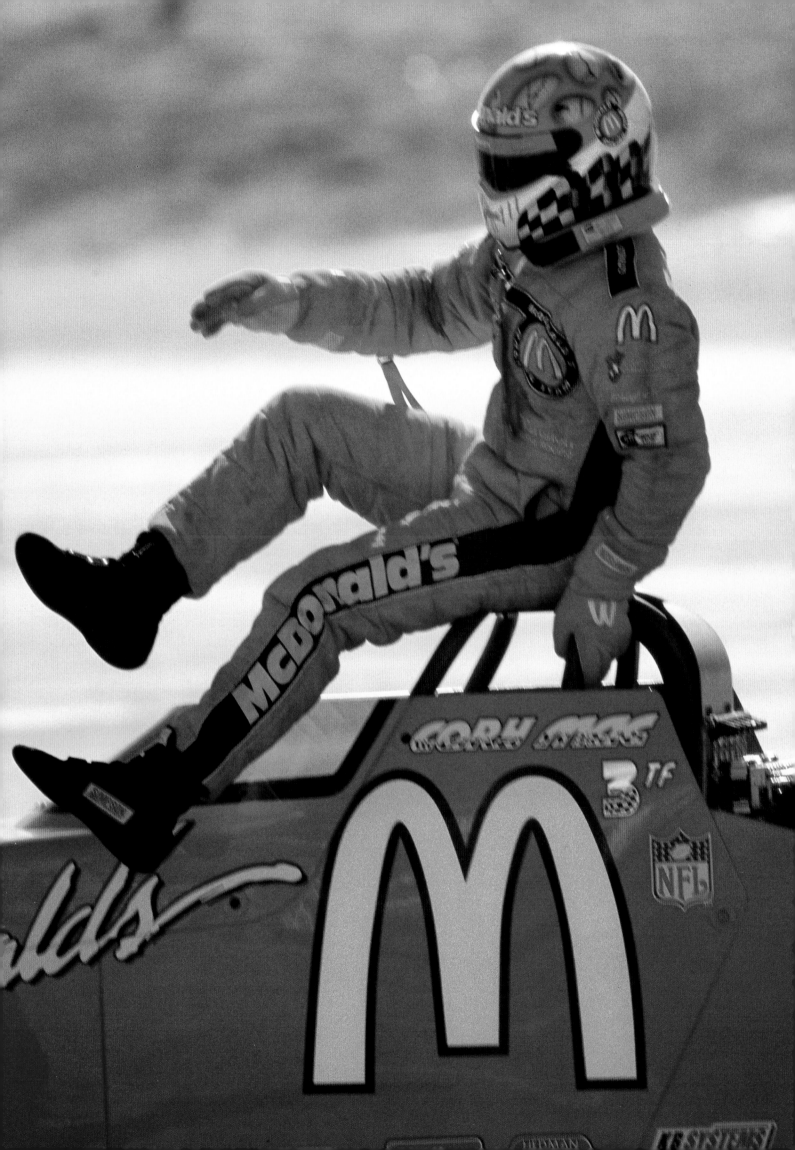

ACE McCULLOCH, 1994

RON McQUEENEY

"All I do is racing," says McQueeney, who made his first visit to the Indianapolis Motor Speedway at age two with his dad and hasn't missed an Indy 500 race since, except when he was in the service. He took his first fan shots from the stands in 1965 and found his way into the pits. For two decades, it has been official, as director of the Speedway photography department. He also follows NASCAR and drag racing. At the U.S. Nationals in Indianapolis, Cory McClenathan and Ed "the Ace" McCulloch screamed through the quarter mile at 300 mph plus to wins in successive years. "I like the spectacle of drag racing—the color of the event, the cars, the drivers," says McQueeney. He shoots static shots, but likes the trickier challenge of speed. "You take a car out on the racetrack, and if you can read the lettering on the tires, it looks like it's standing still," he says. "You have to blur it."

CORY MAC, 1995

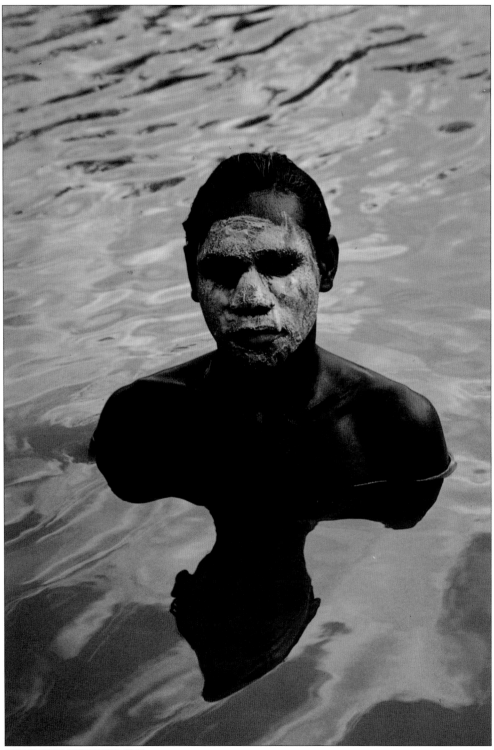

AUSTRALIAN ABORIGINE, 1995

SAM ABELL

"Stay this moment," implored writer Virginia Woolf. Photographer Sam Abell has taken the words to heart, seeking to capture a moment forever with each frame and titling a 1990 collection of his images with Woolf's phrase. "I want the viewer to have the feeling of being present within the photograph," he says. Known for photographic biographies of such luminaries as writer Lewis Carroll and painter Winslow Homer, Abell's subject matter, too, has an eternal quality. The aboriginal Australian swimming in a billabong *(above)*, smeared

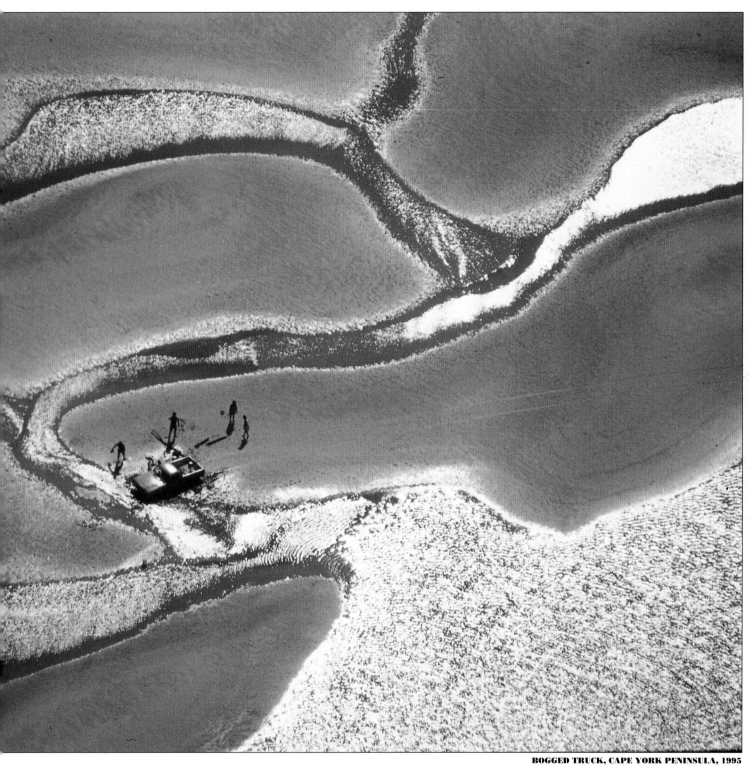

BOGGED TRUCK, CAPE YORK PENINSULA, 1995

with mud in an echo of the face-painting of his ancestors, captures the timelessness of his race. "It's an iconographic image of the oldest continuous culture on earth," says Abell. "This photograph speaks to that primal place that aborigines have in world culture."

After doing articles and a book Down Under, Abell is partial to the continent. A recent *National Geographic* assignment took him to the wild northeastern corner of Australia, Cape York Peninsula, where he saw these travelers losing a race with the tide. They signaled

his plane, he radioed Brisbane, more than 1,000 miles away, and a truck arrived with a winch in the nick of time. "I like these photographs I call dioramas, where the figures are scaled down, set in a vast and surreal landscape."

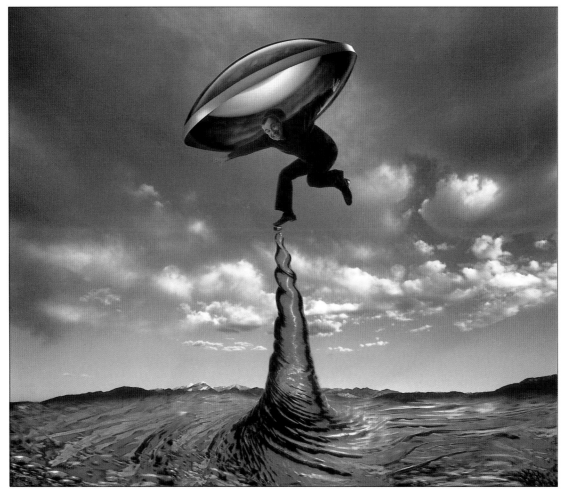

SELF-PORTRAIT, 1996

RYSZARD HOROWITZ

"The self-portrait symbolizes a photographer balancing the weight of his whole medium," says Horowitz of his playful self-image carrying a gigantic lens *(above)*. Like much of his work, it is a composite, using photographs of an alpine sky, himself in his New York studio, and a swirl of water created with a special effects machine. "I call them photocompositions, and I call myself a photocomposer," he says with tongue in cheek. A painter by training in his native Poland, Horowitz begins with a notebook sketch. Long before it was possible to combine images with a computer, he did his magic in the darkroom. Instead of interpreting his compositions like "Water Bird" *(right)*, he says, "I like people to read into them their own meaning. I like allegory and anecdote." His credo is any reaction rather than boredom.

WATER BIRD, 1996

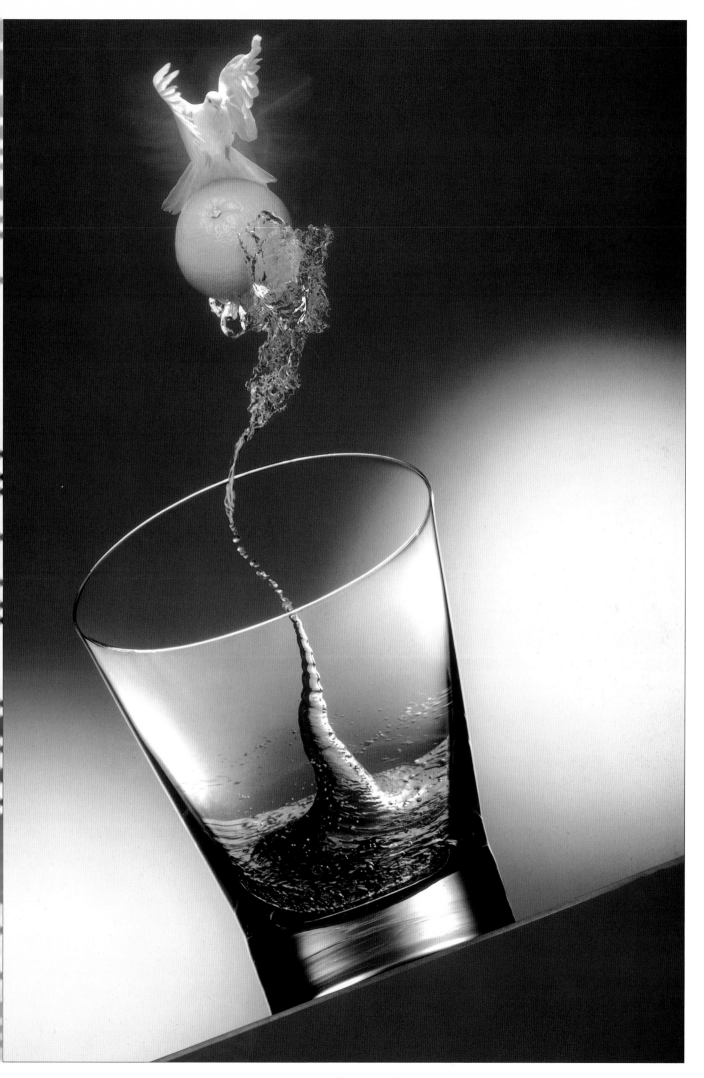

TECHNICAL INFORMATION

BARBARA BORDNICK

BERNADETTE IN FEATHERS, 1995

For a photographer who has made her name synonymous with elegant designs by the world's leading couturiers, it is no surprise that Barbara Bordnick found herself quite taken with the look, feel and whisper-quiet operation of the EOS-1N. Shot on ISO 1000 color film with Canon's EF 70-200mm f/2.8L USM zoom lens, this "outstanding outtake" of model Bernadette from a *New York Times Magazine* shoot illustrates the considerable talents of makeup artist Alberto Fava and stylist/editor Barbara Turk. Bordnick remembers that the first time she used the EOS-1N was for a shoot of a world-famous actor on the street in New York's photo district. Apparently the jaded pros paid little interest to the actor but were like little kids in the candy store wanting to know exactly how the new camera worked.

ARNOLD NEWMAN

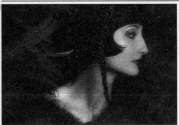

TIBOR HUSZAR, 1995

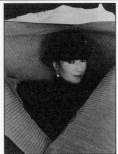

TETSUKO KUROYANAGI, 1995

Overhead fluorescents, the EF 28-70mm f/2.8L USM zoom lens and Arnold Newman's imagination produced the classic look of his hand-held EOS-1N portrait of Slovak photographer Tibor Huszar. Newman notes that this "shot on the run" black-and-white T-Max 400 image demonstrates the creative opportunities generated by the EOS-1N's high-performance automated exposure and focusing systems and the sharpness and focal flexibility of EF lenses. Photographed with the same camera-lens-film tandem, the meticulously staged portrait of Japanese talk-meister Tetsuko takes full advantage of Newman's patented "virtual north light" bank of tungstens, also illustrating his oft-stated commitment to "never using strobe if I can help it."

CLINT CLEMENS

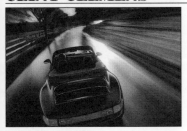

PORSCHE 944, 1995

Known for his top-secret camera techniques, Clint Clemens used the EOS-1N and the fifteen-element EF 20-35mm f/2.8L USM wide angle zoom lens to capture this astounding image of a Porsche Cabriolet in flight. Shot on Ektachrome EPP without special effects filters or supplementary lighting, Clemens's flying Porsche took full advantage of the camera's extensive menu of autofocus and autoexposure functions.

PARISH KOHANIM

ESSENCE OF LIFE, 1995

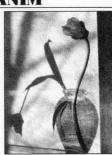

PROGRESSION, 19

"The concept was so nice and spontaneous that I didn't have to get technical—the camera took care of everything else. That's what a tool should do," recalls photographer-illustrator Parish Kohanim about his image *Progression*. On the other hand, Kohanim's Ektachrome EPP photo-composition *Essence of Life* required the full panoply of EF lenses and the EOS-1N's ability to autofocus on a moving object, in this case the water falling into the cupped hands.

MICHAEL FIZER

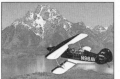

AVIAT PITTS S2B, 1995

RAYTHEON HAWKER, 1995

"Hands down, everything is where you need it," sums up Michael Fizer's reaction to the EOS-1N's ergonomically placed controls and settings. "It's a real paradigm shift." Fizer used the EF 28-70mm f/2.8L USM for the shot of the Aviat Pitts S2B in front of the always spectacular Grand Tetons, and the EF 70-200mm f/2.8L USM for the Raytheon Hawker over Gip Hills, Kansas, captured on Velvia with a KR 1.5 Heliopan warming filter.

ARTHUR ELGORT

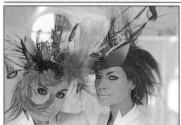

CAROLINE AND MICHELLE, 1995

Push-processed Lumiere and late afternoon daylight combine to give Arthur Elgort's portrait of Caroline and Michelle its remarkable neon-yellow palette. Widely known for his connoisseurship of fine cameras and lenses, Elgort selected the EF 85mm f/1.2L USM to vividly capture this image's luminosity and detail. When not in the studio, Elgort has used the ultra-compact EF 80-200mm f/4.5-5.6 USM zoom lens for everything from shooting in tight spots like the back seat of a car to powerboat races.

ERIC MEOLA

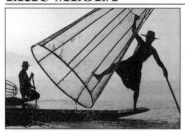

FISHERMEN, BURMA, 1995

"This lens is beyond spectacular," says photographer Eric Meola about the EF 70-200mm f/2.8L USM zoom lens. "It's the best lens in 35mm photography." Meola used the EOS-1N's autofocusing and auto-exposure systems to nail this grab shot on Lumiere film. Commenting on the way the technological transparency of the EOS liberates the photographic experience, allowing him to blend in, Meola says, "I've gone from being a professional to being an amateur."

BETH GALTON

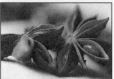

STAR ANISE, 1995

LINEN WITH PEARLS, 1995

"The quick control dial on the back of the EOS-1N is perfect for my small hands," says still-life photographer Beth Galton. She shot *Star Anise* with the EF 100mm f/2.8 Macro telephoto and *Linen with Pearls* with the EF 50mm f/2.5 Compact Macro, using warming gels in front of Mole tungsten studio lights on Ektachrome EPY to produce striking colors that rivet the eye. Galton notes that "the EOS-1N is so much easier to work with, I'm ready to sell my other cameras."

MARY ELLEN MARK

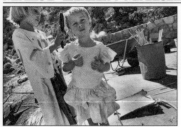

ASHLEY AND SUMMER, 1994

Ultraquiet autofocusing and film advance made the EOS-1N and the EF 28mm f/2.8 wide angle lens a good choice for Mary Ellen Mark's Tri-X portrait of Ashley and Summer, printed on Elite Fine Art paper. Always respectful of the sensibilities of her subjects, Mark says, "The camera is great where you have to work quietly to capture the right moment. Everything is decided for you, so you can capture it."

CHRIS RAINIER

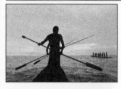

ASMAT WARRIOR CANOES, ASMAT AREA, IRIAN JAYA, 1995

TRADITIONAL SING-SONG DANCE, PAPUA NEW GUINEA, 1995

Far from the streets of Sarajevo, photojournalist Chris Rainier used the EF 20-35mm f/3.5-4.5 USM wide angle zoom to capture these Tri-X images of the indigenous peoples of New Guinea. Setting his EOS-1N to aperture-preferred automatic exposure so that he knew the depth of field, he shot the canoe with natural light and the dance with fill flash from the Speedlite 540EZ on top of the camera.

Always working in difficult shooting circumstances, Rainier says that he appreciates the functionality, location and thumb-based operation of the quick control dial. Expanding on that, he observes, "A great thing about the Canon is that it feels like it was designed by a photographer because all the settings are so logically thought out."

ARTHUR MORRIS

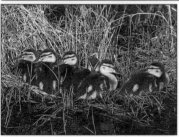

MALLARD BABIES, 1995

Arthur Morris pushed Velvia one stop for this picture of a mallard brood. Morris manually set an EOS A2 equipped with an EF 100-300mm f/4.5-5.6 USM zoom lens to 1/350 second at f/8 to capture this image before the chicks changed their mind. Noting that "the autofocus is beyond science fiction," Morris says he "loves the A2 because it's an incomparable camera for photographing flying birds and swimming ducks."

DOUGLAS KIRKLAND

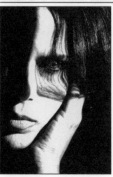

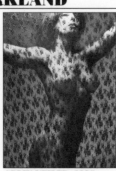

ADLIN VEILED, 1995

ADLIN BY SUNLIGHT, 1995

"Perfect focus, perfect exposure, perfect f-stop" throughout the zoom range, all tie for first place as Douglas Kirkland describes the EOS-1N experience. Shooting with the EF 75-300mm f/4-5.6 IS USM lens, Kirkland shot this stunning sunlit portrait of model Adlin de Domingo on T-Max 100 ultra-fine-grain black-and-white film. According to Kirkland, "The EOS-1N's auto-correcting f-stop and instantaneous focusing allowed me to skip the science and concentrate on the art." Kirkland used Canon's EF 35-135mm f/4-5.6 USM zoom lens and a Balcar 1000 strobe through a softbox to capture the dramatic T-Max nude of Adlin.

DIRCK HALSTEAD

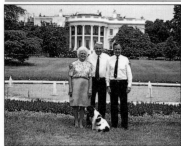

**OUR FRIEND BORIS CAME TO VISIT,
1990**

Time is always of the essence for *Time* magazine White House photographer Dirck Halstead and his ultra-famous subjects. Halstead used the EF 28-70mm f/2.8L USM with whatever daylight was available to get this Fujichrome RDP image of Mrs. Bush, her dog Millie, and two unidentified world leaders. Having little or no time to plan such impromptu photo ops, Halstead notes that "the EOS system's autofocus is very reliable. That's why I was one of the first people covering the White House to use it."

MELVIN SOKOLSKY

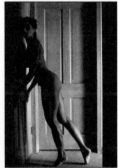

LISTEN, 1995

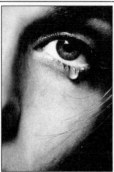

SEE, 1995

"There is no camera on the planet like it," says photographer and film director Melvin Sokolsky of the EOS-1N. His Technical Pan nude was shot with the EF 28-70mm f/2.8L USM, using daylight illumination through a reflector system with a glass door and silk. For his available light Tri-X picture of the tear, Sokolsky used the EF 70-200mm f/2.8L USM zoom lens with an Extender EF 1.4x. He says both lenses are appealing because "they have a mellowness that no other lenses have. The images are sharp, but they don't look like medical photography."

BRUCE DAVIDSON

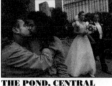

**THE POND, CENTRAL
PARK, SUMMER, 1992**

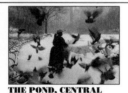

**THE POND, CENTRAL
PARK, WINTER, 1993**

ISO 400 Tri-X black-and-white film processed in T-Max developer diluted 1:7 and printed on PolyMax Fine Art paper gives these Bruce Davidson pictures their distinctive "look." Shot with the aspheric EF 20-35mm f/2.8L wide angle zoom lens, the summer scene was captured at f/11 at the 20mm setting, the winter scene between f/4 and f/5.6 at the 24mm position. Davidson feels the EOS-1N's tracking AI Servo focus is great because "your eye can't focus that fast."

MICHEL TCHEREVKOFF

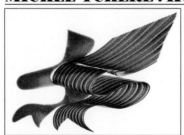

DIGITAL DIRECTION, 1995

A law student turned photographer, Michel Tcherevkoff shot his carefully lit key object with an EF 50mm f/2.5 Compact Macro attached to an EOS A2 on Ektachrome EPP. An expert in digital image editing, Tcherevkoff discovered that once he could drum scan 35mm chromes, he didn't need to shoot 4x5 anymore. About the EOS, he notes, "It gives so many more options than I ever had in the past."

GEORGE LEPP

BUG'S EYE VIEW OF CALIFORNIA POPPIES, 1995

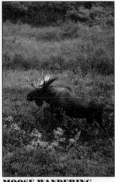

MOOSE WANDERING DENALI TUNDRA, 1995

Over thirteen pounds of glass, steel and brass including a fluorite element are needed to make the EF 600mm f/4L USM telephoto lens that nature specialist George Lepp carried to the high tundra of Denali National Park to get his stunning image of a moose on the prowl. Shot with the Extender EF 1.4x to bring the effective focal length to a cool 840mm, the photo demonstrates the way the EOS-1N's autofocusing and autoexposure allowed Lepp to track the moose, not the camera adjustments. At the other end of the distance spectrum is Lepp's fisheye image of poppies, composed with a right-angle finder and taken with the EF 15mm f/2.8 Fisheye lens at a distance of 8.5 inches at f/22.

DICK FRANK

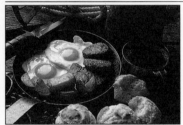

RANCH EGGS, 1995

Autobracketing captivated Dick Frank because it allowed him to keep his eye on the work, not on the camera technique. Using the EF 28-105mm f/3.5-4.5 USM, Frank illuminated his yummy subjects with a custom-made, four-foot, strobe-filled light bank with a Plexiglas diffuser. Shot on daylight balance Ektachrome EPN, Frank spent the better part of a day going from the EOS-1N's automated features to his manual stove to make this cholesterol bomb look good enough to eat.

LARRY SILVER

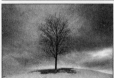

TREE ON HILL, 1995

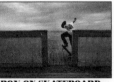

BOY ON SKATEBOARD, 1995

Selenium toning gives Larry Silver's black-and-white images a character less often seen in a profession where so much work is shot in color. For the T-Max 400 picture of the skateboarder, Silver placed a yellow-orange sky-darkening filter over the EF 20-35mm f/2.8L wide angle zoom lens set in the 20mm position and shot his EOS-1N at 1/500 second using shutter priority. Silver used an even more dramatic red filter to take the sky and clouds down in his Tri-X picture of the tree on the hilltop. A much experienced hand, Silver says, "This camera is a new era—it makes previous cameras feel like the horse and buggy."

DAVID MUENCH

NAVAJO SANDSTONE STRIATIONS, 1995

"A great marriage of camera and subject" is how David Muench describes his reaction to using the EOS system with the EF 14mm f/2.8L USM ultra wide angle lens for this Velvia photograph of *Navajo Sandstone Striations*. When photographing other natural formations, Muench explains, "for extension of my eye, the combination of autofocusing and the EF 70-200mm f/2.8L USM zoom lens is amazing."

PETER READ MILLER

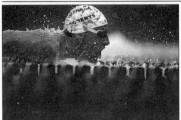

SWIMMER, BARCELONA OLYMPICS, 1992

F/4 at 1/1000 second is what it took for Peter Read Miller to get this Ektachrome picture of a championship swimmer above the aggregated lane markers. Miller used the EF 600mm f/4L USM telephoto lens and the EOS autofocusing system to deal with the technical considerations, while he concentrated on the lateral motion. A big fan of autofocusing, Miller uses the camera daily because it takes the anxiety out of getting things right.

ROBERT FARBER

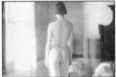

LOOKING AWAY, 1996

HER EYE, 1996

Robert Farber captured these images with the small, lightweight EF 28-105mm f/3.5-4.5 USM mounted on an EOS-1N. *Her Eye* was photographed under available interior tungsten light on PolaPan 35mm instant black-and-white transparency film, and *Looking Away* was shot on Agfapan 400 under straight ambient light. Farber set the camera to manual to intentionally throw out the focus. Liking the EOS system's ease of switching from one mode to another, Farber says, "Once you get used to somebody making your life easier, it's great."

ALBERT WATSON

DANNY HALL, 1991

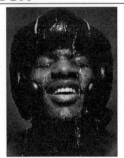

RIDDICK BOWE, ATLANTIC CITY, 1991

Albert Watson has so much faith in his EOS-1N that he uses it as a light meter for his 8x10 work when he isn't busy photographing the likes of Riddick Bowe. The available light Tri-X image of Danny Hall was shot through a contrast-enhancing yellow filter with the EF 80-200mm f/4.5-5.6 USM lens. Watson used a Norman bare-bulb strobe without diffuser and the EF 80-200mm f/2.8L zoom lens for his Tri-X portrait of heavyweight boxer Bowe. Both pictures were printed on Galerie paper. About the EOS-1N's autofocusing and auto-exposure systems, Watson recalls, "One night, I stuck the camera out the window of a speeding cab in Cairo and just shot. The pictures came out so good it's scary."

NORMAN McGRATH

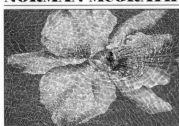

HAWAIIAN HYDROPHYTE, 1995

Architectural photographer Norman McGrath used the EF 70-200mm f/2.8L USM to capture the undulating symmetry of the swimmers in a hotel pool near Waikiki Beach. Shot with an EOS-1N at 1/250 second between f/11 and f/16 under natural light on Provia, McGrath got the desired abstract look by composing and cropping with the zoom while the camera managed the autofocusing. A big fan of the EF family of lenses, especially for his architectural work, McGrath says, "The EF 14mm f/2.8L USM is possibly the sharpest lens I have ever used."

JACK REZNICKI

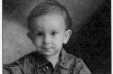

HUNTER, 1995

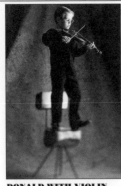

DONALD WITH VIOLIN, 1995

Child portraitist Jack Reznicki chose the TS-E 90mm f/2.8 tilt-shift lens with an 81B warming filter to direct the viewer's attention to the violinist's face in this Dynalight and Chimera bank illuminated Ektachrome EPP photograph. To get both a sharply focused face and blurred edges on his portrait of Hunter, Reznicki attached the EF 80-200mm f/2.8L to his EOS-1N and "dragged the shutter" by setting the camera to 1/8 second at f/5.6-6.8, with the strobe on the boy and tungsten studio lights on the background.

JAMES WOOD

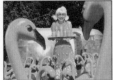

FLAMINGOS, 1995

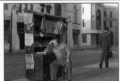

NEWSSTAND, 1995

Lumiere was used to capture both of these EOS-1N pictures from the imagination of photographer, artist and teacher James Wood. For the mixed daylight and tungsten lit photograph of the newsstand, Wood used the EF 70-200mm f/2.8L USM lens and zone focusing to record the Edward Hopper–like effect. The EF 20-35mm f/2.8L wide angle zoom with a #1 diffusion filter and fill flash allowed Wood to get the very Hollywood image of the woman serving drinks to the pink flamingos. A serious fan of the EOS system, Wood notes, "My students at the Academy of Art College in San Francisco love these cameras for class work and for assignments."

SARAH MOON

SWIMMING I, 1996

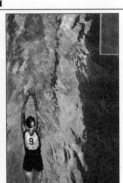

SWIMMING II, 1996

EOS autofocusing was the key to tracking the subjects in Sarah Moon's toned Tri-X photographs of swimmers. Taking full advantage of the autobracketing system, which was set for 1/2 stop under, 1/2 over, Paris-based Moon worked with the EF 70-200mm f/2.8L USM zoom lens to compose these stylized available light plus strobe images.

GREG GORMAN

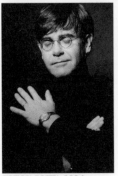

ELTON JOHN, 1994

LEONARDO DI CAPRIO, 1994

With natural light from a skylight against seamless, Greg Gorman used the EF 80-200mm f/2.8L to capture Elton John on Tri-X rated at ISO 250. A rooftop studio high over Los Angeles provided the right kind of natural light for Gorman's portrait of Leonardo di Caprio on Plus-X rated at ISO 80. Speaking about photographing the famous and the celebrated with the EOS system, Gorman notes that "the autofeatures allow me to get a lot more spontaneity into the portraits."

HARVEY LLOYD

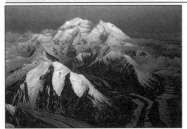

MOUNT DENALI AT DAWN FROM 22,000 FEET, 1995

Shot as the first light of day illuminated the peak of Alaska's Mount Denali, this image "couldn't have been done without the EOS-1N, the EF 50mm f/1.0L USM, the KS-8 gyrostabilizer, and a damn good pilot," says photographer Harvey Lloyd. Pushing Velvia to ISO 100, he shot this airborne vista wide open at 1/30 second. Because he does so much aerial photography in cramped spaces under extremely difficult environmental conditions, Lloyd appreciates that the EOS-1N's fast film rewinding allows him to run four different camera/lens combinations simultaneously. About the EOS-1N's autobracketing, he says, "All you have to do is see."

PAUL BOWEN

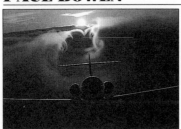

HAWKER 800 XP, 1996

"For me, switching to the EOS-1N was like going from the typewriter to the computer," explains airborne photographer Paul Bowen. "I feel like a kid with a new toy. The autofocus and the EF 75-300mm f/4-5.6 IS USM image stabilizing lens is great when you're bouncing around in a fifty-year-old B-25 at 200 miles per hour and you can't see with the sun in your face. I love the autobracketing. I can't fiddle around when it's so cold. I have to give up before the camera does."

BRIAN LANKER

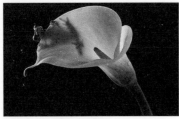

RED-EYED TREE FROG (Agalychnis callidryas), 1994

Brian Lanker used the EF 200mm f/2.8L USM telephoto lens with an extension tube and the EOS-1N to capture his photographs of charming amphibians. Setting his EOS-1N to its AI Servo focusing mode, Lanker recorded the frog and the red flower *(title page)* under natural light on Velvia film at 1/500 second at f/4. He added studio strobes to his kit for the image of the frog and the calla lily, shot at 1/125 second at f/8. Noting that his subjects had no use for his stage instructions, Lanker says, "The focusing points were especially helpful in taking the photographs of the tree frogs."

STEVE KRONGARD

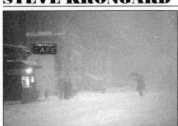

BLIZZARD OF '96, 1996

Bone-chilling cold and blinding snow made the EF 70-200mm f/2.8L USM zoom a perfect choice for Steve Krongard's *Blizzard of '96*. Shooting on tungsten-balanced Fujichrome RTF, he pushed the film 1/4 stop to accentuate the contrast and the blue coloration. Recalling the extremely difficult conditions, Krongard says, "I was huddled in a doorway trying to stay out of the cold and high winds. Because of the EOS-1N's autofocus and autoexposure and the way the camera feels in my hand, all I had to worry about was finding an image that was interesting."

J. BARRY O'ROURKE

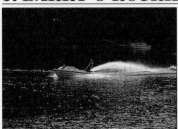

WATERSKIER, 1995

Old standby Ektachrome EPX was used by J. Barry O'Rourke to record this carefully planned grab shot of a late afternoon sunlit waterskier on Connecticut's Housatonic River. Having noticed this photo opportunity a few days before, O'Rourke set up his EOS-1N with the EF 300mm f/4L USM telephoto lens on a tripod in just the right place. Shooting from 100 yards away at wide open at the fastest shutter speeds the available light allowed, he found "the follow focus remarkable and the autoexposure amazing."

HENRY WOLF

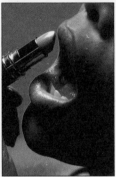

MAKEUP, 1995

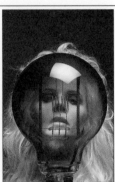

STUDIO LIGHT, 1995

Henry Wolf likes his watt seconds— 10,000 to be exact. He fitted his EOS-1N with the EF 100mm f/2.8 Macro to get this strobe-illuminated Kodachrome 25 photograph of a model putting on lipstick. For the remarkable Kodachrome portrait of a model looking through a 5,000-watt Hollywood klieg light, Wolf selected the EF 300mm f/2.8L USM. Although he finds "the camera is like driving a Ferrari in traffic, the lenses are fantastic."

GIL SMITH

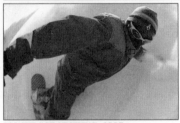

IGUCHI SCRATCHING, 1995

Automobile advertising photographer Gil Smith picked the EF 15mm f/2.8 Fisheye lens to capture this Velvia picture of a snowboarder. Setting the EOS-1N to a fixed shutter speed of 1/45 second and a fixed distance to achieve the blurring snow effect, Smith placed an 81C warming filter in the lens's rear filter compartment and shot with autoexposure engaged. Photographed with natural light at 11,000 feet in the highlands above Aspen, the technically difficult image demonstrates what Smith calls "the perfect marriage of lens and camera."

WALTER IOOSS, JR.

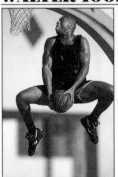

MIAMI SLAM, 1994

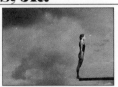

SPRING BREAK, FORT LAUDERDALE, 1993

"Autofocus! I have lost the art of manual focus." So notes sports photographer Walter Iooss, Jr., about the EOS-1N and the EF 80-200mm f/2.8L lens he used to capture the strobe-fill Velvia image of the diver, shot during Fort Lauderdale's spring break. Although he caught the basketball player in mid-flight with the EF 400mm f/2.8L USM, he remains a big fan of zoom lenses. According to Iooss, "The zoom lenses have changed the face of photojournalism. With just two lenses, you go from 17mm to 350mm."

CAROL KAPLAN

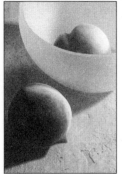

PEACHES, 1995

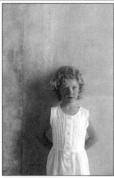

WYATT, 1995

Careful lighting and photographic planning go into Carol Kaplan's stylized still life of the bowl and peaches and her portrait of the little girl, both shot on Provia. Kaplan used the sixteen-element EF 80-200mm f/2.8L zoom lens and the EOS-1N's fast autofocusing to capture her strobe-illuminated, 5R+5Y+weak diffusion–filtered portrait of Wyatt. Kaplan took the tilt-shift TS-E 90mm f/2.8 lens to its limits to give the wafer-bank–lit picture of the peaches an 8x10 view camera feel.

WILLIAM NEILL

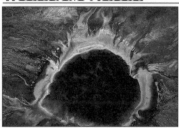

GRAND PRISMATIC SPRING, AERIAL,
YELLOWSTONE NATIONAL PARK, 1995

The EF 70-200mm f/2.8L USM lens set at wide open was the key to this airborne image of the Grand Prismatic Spring in Yellowstone. Sporting an EOS-1N, natural wonder specialist William Neill had four passes from a banking plane to get it right. Shooting on aperture preferred, he took full advantage of both autobracketing to deal with unpredictable natural light and autofocus to compensate for changes in the airplane's elevation.

Commenting on all the photographic adjustments he could make while shooting with the quick control dial on the camera back, Neill says, "I may not be able to brush my teeth, but I can take photographs."

JAMES NACHTWEY

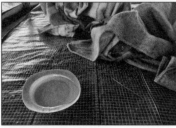

SOUTHERN SUDAN, 1992

 "The autofocusing is faster than I ever was," notes photographer James Nachtwey about the EOS-1 he used to record this Tri-X available light image of the famine in southern Sudan. Printed on Polycontrast III RC paper, this picture was taken with the EF 20-35mm f/2.8L zoom lens. "Once I learned to adjust to the zoom, it

allowed me to fine-tune compositions quickly," Nachtwey observes. "The EOS is streamlined, lightweight, balanced; it even operates on manual. It's just a good design."

TIMOTHY GREENFIELD-SANDERS

CALVIN KLEIN, 1995

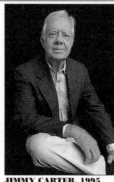

JIMMY CARTER, 1995

"When you don't have enough time because the subject is busy or famous or both, the EOS camera's autofocusing is great," says Timothy Greenfield-Sanders. "It's wonderful for reportage because you know the autoexposure will take care of everything." He used the EF 70-200mm f/2.8L USM to get this strobe-illuminated T-Max shot of Calvin Klein, "who knows his way around cameras and lights," as the photographer observes. Busier now than when he was president,

Jimmy Carter gave Greenfield-Sanders exactly nine minutes to shoot a series of portraits, including this one on Ektachrome EPP transparency film.

SHEILA METZNER

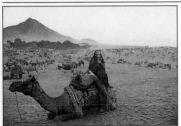

PHOEBE, PUSHKAR, 1995

A polarizer and an 81A warming filter were added to an EF 70-200mm f/2.8L USM zoom lens to get this Sheila Metzner image of Phoebe and a well-appointed camel onto Ektachrome P-1600 EPH push-processing film. Having taken full advantage of the EOS-1N's many features, Metzner says, "This camera has totally changed my life. I feel like I am seeing for the first time." To get this particular naturally lit exposure, she used the autobracketing, along with autofocusing.

JOEL MEYEROWITZ

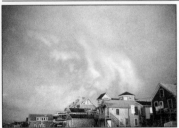

DAWN'S EARLY LIGHT, PROVINCETOWN, 1995

Featuring the now classic Meyerowitz look, this Kodachrome 64 image of Provincetown at dawn was shot with the EF 35mm f/2 wide angle lens. A devotee of manual settings, Meyerowitz set his EOS-1N at 1/30 second at f/4 to produce the desired exposure. Commenting on the EOS system's autofocusing capabilities, Meyerowitz says that he plans to use the camera for a commercial shoot for a running shoe manufacturer.

ANTHONY EDGEWORTH

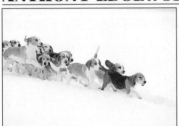

BEAGLES, 1995

"Great glass" is the phrase Anthony Edgeworth chooses to describe the EF 300mm f/2.8L USM telephoto and Extender EF 1.4x he used to record these beagles trudging through the Pennsylvania snows. Captured on Kodachrome 200 without filters or fill flash, this image took full advantage of the EOS-1N's AI Servo focus tracking system. According to Edgeworth, "The EOS is a very powerful camera, perfect for action and guys who wear glasses. It really works."

CO RENTMEESTER

SWISH, 1992 SPEED, 1993

Co Rentmeester chose Velvia film to record these EF 20-35mm f/2.8L images of a surfer and a cyclist. An expert at panning or swish shots, Rentmeester sets his EOS-1N for slow shutter speeds and moves the camera at the same speed as the subject. To get his signature wind-blurred background for the surfboarder in sun-splashed Maui, he placed a three-stop neutral density filter in front of the lens, taking his effective shooting speed down to ISO 6.

LARRY DALE GORDON

BHUTANESE FESTIVAL
DANCER, 1994

TEXTURES SERIES, THE
FEATHER, 1995

"I used the EF 80-200mm f/2.8L—my favorite lens—to flatten out the background and isolate this Bhutanese festival dancer from the rest of her troupe," says Larry Dale Gordon about this Duchamp-like study in color and motion. "Even though she is quite a distance away, the EOS metering system nailed the exposure." Carefully planned camera-based double exposure is the key to Gordon's striking image of a nude with a feather. Observes Gordon, "The computer is faster for this kind of work, but the camera is a lot more fun."

PAUL ARESU

BICYCLE SERIES, #4,
1995

BICYCLE SERIES, #1,
1995

Shot with the six-element TS-E 90mm f/2.8 tilt-shift lens at wide open, Paul Aresu's stunning images take full advantage of the EOS-1N's ability to automatically nail the exposure under any kind of lighting conditions—in this case, Mole and mini-Mole studio lights. Using daylight balanced Lumiere film with coloring gels over the Moles, Aresu created a translucent, Day-Glow–like effect. The sports-minded photographer notes that the EOS-1N's operating speed and quiet motor drive are ideal for shooting pro tennis matches.

JOYCE TENNESON

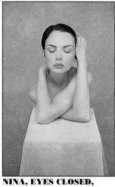

NINA, EYES CLOSED,
1995

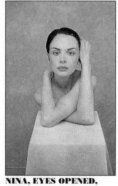

NINA, EYES OPENED,
1995

Joyce Tenneson set the EF 28-105mm f/3.5-4.5 USM lens "somewhere in the middle" to make these Ektachrome EPP photographs of her friend Nina with the EOS-1N. With the exposure manually set, Tenneson relied on the autofocusing system so that she "could concentrate on the subject's expression" in these strobe- and softbox-illuminated studies.

DAVID R. STOECKLEIN

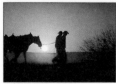

DAY'S END, 1996

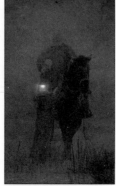

WINTER RESCUE, 1996

Six thousand grams of glass and barrel go into the EF 400mm f/2.8L USM super-telephoto lens that photographer and history buff David R. Stoecklein used to capture these icons of the American West. Shooting with Lumiere, Stoecklein relied on the unfiltered light of the setting sun to illuminate his EOS-1N picture of the two cowboys. He used a wind machine and snow blower to enhance the blizzardlike sensation in the photograph of the lantern-lit horse and rider. Stoecklein finds that "the autofocusing system is so reliable it allows me to focus on composition and lighting."

GREGORY HEISLER

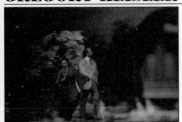

MADAMA BUTTERFLY, 1994

The tilt-shift TS-E 90mm f/2.8 gives view-camera specialist Gregory Heisler the high level of control of focus and depth of field he gets from his 8x10 and 4x5 sheet film cameras. An avid user of Canon's other tilt-shift lenses, the TS-E 24mm f/3.5L and the TS-E 45mm f/2.8, Heisler reports that he likes the way he can use this family of lenses to concentrate the viewer's interest by intentionally throwing the subject out of focus and shooting wide open to reduce depth of field, as he has done in this Provia image of Madama Butterfly.

DENIS REGGIE

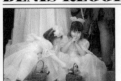

FLOWERS, FLOWERS, 1996

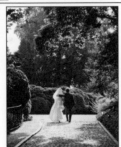

GARDEN WALK, 1996

Wedding photographer Denis Reggie likes to set the EOS-1N's aperture priority at wide open to minimize depth of field, as can be seen in his Tri-X image of fleet-footed newlyweds on the way to their wedding reception. Shot with the EF 28-70mm f/2.8L USM zoom lens racked out to 70mm, this one-handed grabber shot couldn't have happened without the camera's autofocusing and autoexposure systems. The Ektapress Plus 400 candids of the flower girls illustrate Reggie's belief that "if your subject is aware of her picture being taken, you lose the reality of the moment. Quiet, rapid-action equipment lets me get photographs that wouldn't have happened otherwise."

NICK VEDROS

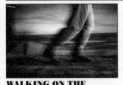

WALKING ON THE INDOOR DOCK OF THE BAY, 1995

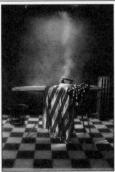

IRONING OUT AMERICA'S PROBLEMS, 1996

Comet strobes, Chimera softboxes and a few well-placed tungsten studio lights were used to illuminate both of photographer Nick Vedros's Ektachrome EPP images. A meticulous craftsman who takes a Polaroid every time he adds or changes a light, Vedros used the EF 28-70mm f/2.8L USM zoom lens to create these dream-like EOS-1N pictures. Noting that "the EOS-1N is my favorite 35 because it's so easy to use," Vedros adds that he was "amazed at the lens quality at maximum aperture."

PATRICK DEMARCHELIER

MACHU PICCHU, 1996

Intentionally overexposed Kodak Pro 400 PMC color negative film is the key to the understated palette of Patrick Demarchelier's photograph of a model surveying the cloud-wrapped ruins of Machu Picchu. Using the EF 28-70mm f/2.8L USM with the EOS-1N set to manual exposure, Demarchelier took full advantage of the diffuse available light unique to the Peruvian Andes.

RON McQUEENEY

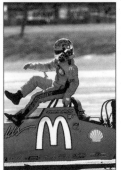

CORY MAC, 1995

ACE McCULLOCH, 1994

Ron McQueeney chose the EF 500mm f/4.5L USM, an international standby for auto racing photography, to capture this Kodachrome 200 image of Cory "Mac" McClenathan jumping out of his drag strip racer at the end of a run. For his photograph of Ed "the Ace" McCulloch, McQueeney selected the EF 80-200mm f/2.8L with aperture priority on Lumiere film. A thirty-year veteran of the race car circuit, McQueeney says the reason he uses the EOS-1N in such a rough and tumble environment is "it's a very sturdy camera, a very necessary thing for a professional in my business."

SAM ABELL

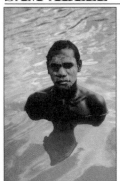
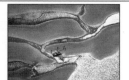

BOGGED TRUCK, CAPE YORK PENINSULA, 1995

AUSTRALIAN ABORIGINE, 1995

"I found the autofocusing and zoom lens transforming," says Sam Abell. "It's a new way of photography." Shot with the EF 28-70 f/2.8L USM zoom lens, these natural light images of an aboriginal youth named Trumaine and Australia's Cape York Peninsula were captured without filtration on Provia transparency film. Abell notes that the "flawless autoexposure and razor-sharp autofocusing systems of the EOS-1N allow me to be a more spontaneous photographer."

RYSZARD HOROWITZ

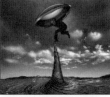
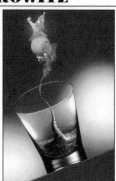

SELF-PORTRAIT, 1996

WATER BIRD, 1996

Uninterrupted full-time viewing through the EOS-1N RS's nonmoving, hard-coated pellicle mirror provides photocomposite maestro Ryszard Horowitz with an unprecedented level of photographic control. He notes that because of the extensive planning and preparation that go into the creation of each of his compositions, "it's critical for me to be able to see the picture at the exact moment of exposure." Horowitz describes his work flow as follows: He makes a sketch, shoots each of the elements, makes a collage and then directs the post-production on a Shima Seiki Modulo 450 Digital Work Station.

ABOUT
THIS PROJECT...

EXPLORERS OF LIGHT was created by a team of people who share an excitement for photography and exceptional images. Will Hopkins and Mary K. Baumann brought their design expertise and knowledge of great photography to the project. Their limitless enthusiasm was responsible for bringing together all the critical elements of image, text and planning. Along with them, Tom Ettinger offered his valuable guidance in the book publishing industry.

At Canon, members of the Camera Division under the direction of Ted Ando worked closely with the participating photographers. This project was conceived by Gene Ikeda, David Metz and Michael Newler of the Professional Markets Department as a special opportunity to define the state of the art in 35mm photography while offering unusual creative freedom to the photographers. Newler provided the day-to-day liaison with each of the artists to bring together this extraordinary collection of images. Chuck Westfall added his expertise, and Joe Delora from Canon Professional Services provided invaluable assistance. Finally, Lou Desiderio from The Rowland Company contributed to the success of this project.